LIVERPOOL
IN
50
BUILDINGS

IAN COLLARD

AMBERLEY

First published 2016

Amberley Publishing, The Hill, Stroud
Gloucestershire GL5 4EP

www.amberley-books.com

British Library Cataloguing in Publication Data.
A catalogue record for this book is available from the British Library.

ISBN 978 1 4456 5895 7 (print)
ISBN 978 1 4456 5896 4 (ebook)

Typesetting and Origination by Amberley Publishing.
Printed in Great Britain.

Contents

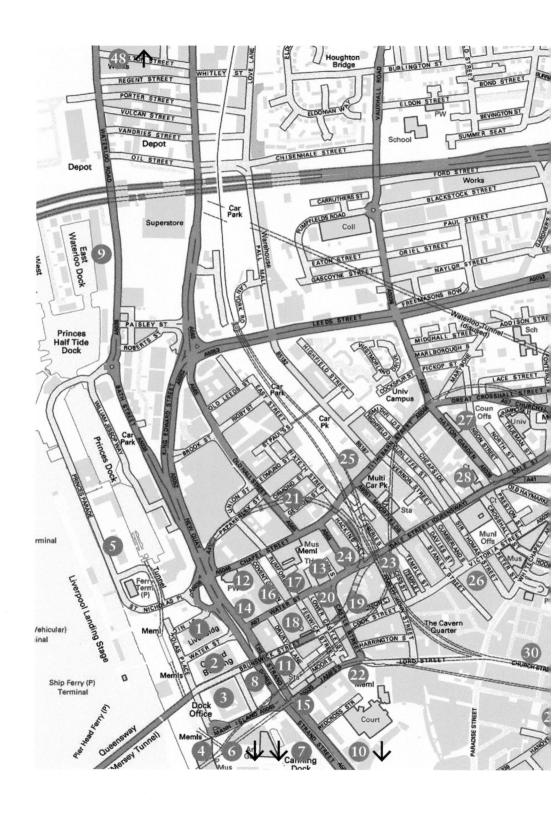

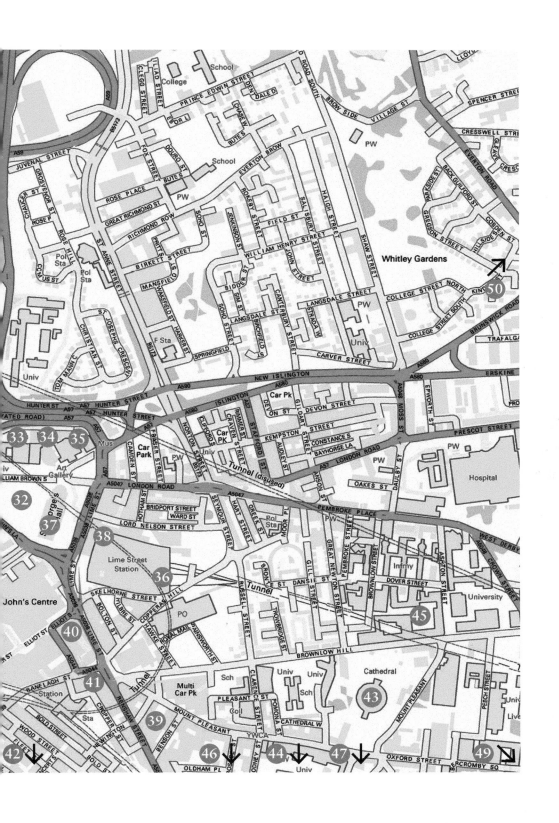

Introduction

It was at the end of the seventeenth century that trade to America began to expand, with the importation of West Indian sugar, Virginian tobacco and the increase in exports of Lancashire textiles. Exported through Liverpool, the coalfields were developed across Lancashire. Sugar refineries, salt and glassworks and metal crafts and potteries were established in the town and Cheshire rock salt was traded through the port.

By 1698, the town had twenty-four streets and the population was over 6,000. Liverpool became a parish the following year and a second parish church was built in 1704 and dedicated to St Peter, surviving until it was demolished in 1922. Involved in the tobacco trade, Sir Thomas Johnson was a major businessman in the town. He was also elected a Member of Parliament until, following customs irregularities, he had to give up his seat in 1722 after representing the borough for twenty-one years.

In 1710, Thomas Steers began the production of the first wet dock in the town and it was opened in 1715; Paradise Street and Whitechapel were built on the sections of the Pool that were drained following the construction of the new dock. In 1726, improvements were made to the road that ran from Liverpool to Prescot by a Turnpike Trust and this was extended to Ashton in Makerfield years later. The roads from Liverpool to Preston and Birkenhead to Chester were also made turnpike roads at the end of the century and a stagecoach service between Liverpool and London began in 1761. An Act of Parliament was passed in 1720 making the River Mersey and River Irwell navigable from Liverpool to Manchester. Further acts were passed to make the River Douglas navigable between the River Ribble and Wigan in 1719 and the River Weaver between the Mersey and Northwich. The Sankey Canal brought coal to Liverpool from St Helens and the Bridgewater Canal, Grand Trunk and the Leeds and Liverpool Canals were completed.

The population of the town increased to 20,000 in 1750 and then to 80,000 in 1800. The number of ships using the port grew from 102 in 1700 to 4,746 in 1800 and land was developed, creating Hanover Street, Park Lane and Duke Street; Williamson Square, Clayton Square, Cleveland Square, Wolstenholme Square and St Paul's Square were also completed. The Blue Coat School for orphan boys opened in 1708, the Royal Infirmary in 1745–49 and the Seamen's Hospital in 1752. The town hall was constructed between 1749 and 1754 and was reconstructed in 1795 following a serious fire.

At the beginning of the nineteenth century, the main trade through the port was to and from the West Indies. Trade with the United States increased gradually and the American Chamber of Commerce was founded in Liverpool in 1805, the Canadian and Newfoundland trade increasing at the same time. The port had improved its trade with the British colonies throughout the seventeenth and eighteenth centuries – the London merchants preferred to ship goods from America to Liverpool and transport them by land to the south of England. The Cotton Exchange had been erected in Exchange Buildings behind the town hall in 1803–08 and the corn merchants built their own exchange in Brunswick Street. A new

Cotton Exchange was erected in Old Hall Street in 1906. Geographically, the port took advantage of providing the Lancashire cotton industry with a convenient way of importing their raw materials and shipping their products around the world.

The Municipal Reform Act 1835 ended the Common Council, which from 1750 had discouraged the admission of new freemen by purchase. Consequently, people like William Roscoe were debarred from the council and from voting at mayoral and parliamentary elections. Bribery and corruption was rife and Liverpool was described as being 'the biggest rotten borough in England'.

The population of the city in 1895 was 503,967, increasing to 685,276 by 1901. The following year, the districts of Garston, Aigburth and Allerton – extending 1,673 acres with a population of 17,288 – were annexed. In 1903, the population was around 717,000 and the area of the city 14,909 acres. Bootle was granted a charter as an independent borough in 1868 and in 1895 Walton, Wavertree, West Derby and Toxteth became part of Liverpool. Garston was added in 1902, Fazakerley in 1905, Allerton, Childwall, Little Woolton and Much Woolton in 1913, the remainder of West Derby and Croxteth in 1928 and Speke in 1932.

Liverpool was granted city status by royal charter in 1880 when the Roman Catholic Church made Liverpool the seat of a new diocese that included part of Chester and south-west Lancashire; two great cathedrals were built in the city in the twentieth century. The City of Liverpool has changed dramatically in the last 100 years but the majority of the buildings in the city centre were constructed in Victorian times and still retain their charm and distinctive character. It is a city steeped in history but one which is also looking forward to its rightful place in modern Britain. It is the country's second largest port and has been the major gateway for people arriving from Northern and Southern Ireland.

Over 8,000 people work in major firms in the commercial district of the city. The area around Old Hall Street was rebuilt in the 1970s and many of the Victorian buildings have been converted to residential accommodation. The former Littlewoods centre was refurbished and high-quality office space was provided in new buildings such as the Beetham Tower, completed in 2004. Liverpool was granted World Heritage Site status in the same year for the inheritance of nineteenth- and early twentieth- century buildings and its role in world history. The city pioneered technology in such areas as construction in cast iron, the world's first intercity railway and the world's first enclosed dock. The World Heritage Site covers the Pier Head, Albert Dock Conservation Area, Stanley Dock Conservation Area, Castle Street Historic Commercial District, William Brown Street Cultural Quarter and the Lower Duke Street Merchants Quarter. A buffer zone was designated around the World Heritage Site following a recommendation by UNESCO to give the area additional protection. UNESCO declared that the structures of the port and city are an exceptional testimony to mercantile culture and noted the role the city played in influencing globally significant demographic changes, both through its role in the transatlantic slave trade and as the leading port of mass European emigration to the New World.

In 2007, Liverpool celebrated its 800th anniversary and became European Capital of Culture the following year. The city centre has been transformed recently by the opening of the new Liverpool One shopping development; Grosvenor's £1 billion project provides retail, leisure and residential facilities and office accommodation and includes the provision of large department stores, hotels, a cinema, cafés, restaurants, bars and a new bus station. There are further plans to regenerate the city centre to ensure that it remains one of the major tourist, commercial and business centres of the north-west of England.

The city has over 2,500 listed buildings – twenty-seven are Grade I-listed and eighty-five are Grade II-listed. It has a greater number of public sculptures than any other place in the UK aside from Westminster and more Georgian houses than the city of Bath. It has been described by English Heritage as England's finest Victorian city even though many of the buildings were either lost during the Blitz or sustained German bombing during the Second World War.

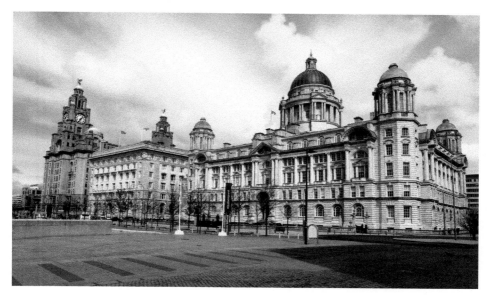

The Royal Liver Building, Cunard Building and the Port of Liverpool Building at the Pier Head.

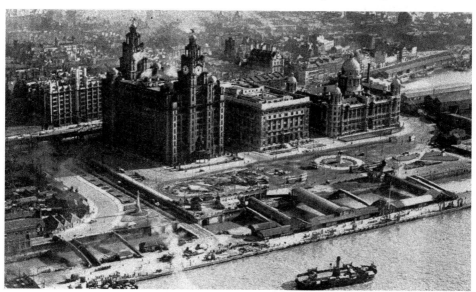

An older image of the Pier Head.

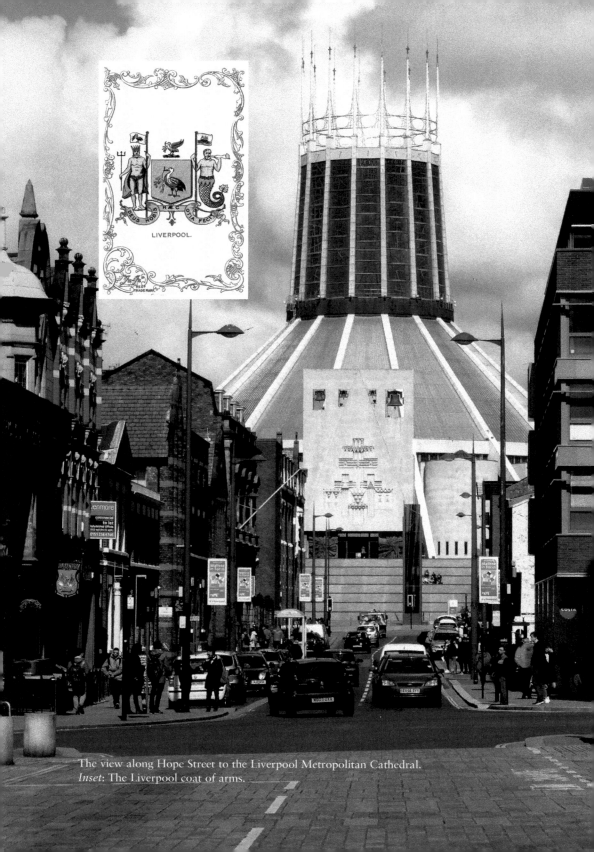

The view along Hope Street to the Liverpool Metropolitan Cathedral.
Inset: The Liverpool coat of arms.

The 50 Buildings

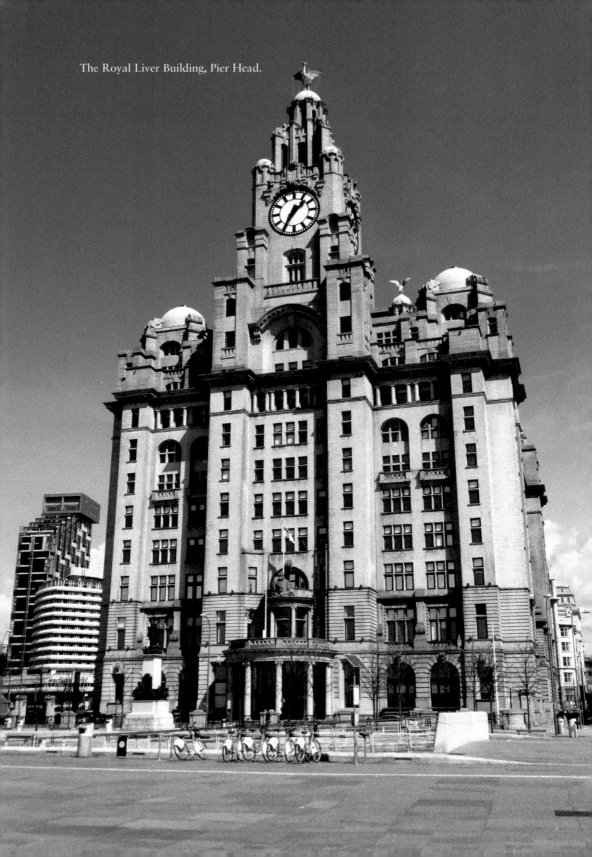

The Royal Liver Building, Pier Head.

1. Royal Liver Building, Pier Head

As there were over 6,000 employees in the Royal Liver Group in 1907, the company felt that they needed larger premises and approval was given for the construction of the Royal Liver Building at the Pier Head, near to the recently constructed Port of Liverpool Building. It was designed by Walter Aubrey Thomas and the foundation stone was laid on 11 May 1908.

The building was officially opened by Lord Sheffield on 19 July 1911 and was also constructed using reinforced concrete faced with granite. The building incorporates two clock towers, the clock faces are 25 feet in diameter – which are larger than those on Big Ben in London – and were the largest electronically driven clocks in Britain. The clocks were originally called George clocks as they were started at the precise moment that George V was crowned on 22 June 1911; electronic chimes were added in 1953.

The building is 301 feet long, 178 feet wide, 170 feet high to the main roof and 295 feet to the top of the main towers. It contains a floor area of 40,000 square yards, 50 miles of heating pipes and 25 miles of electric cables. There are eleven storeys, and each of the main towers has six storeys, making seventeen in all. Eighteen lifts are provided, fifteen of these for passengers. The two main entrances give access to large halls and corridors and the entrance facing the river has a large portico. The Water Street entrance is embellished with a balcony of pierced balustrades and pedestals with carved scroll.

The Liver birds, designed by Carl Bernard Bartels, stand at the top of each tower with one bird overlooking the city and the other facing the river. Legend says that if one of the birds were to fly away then Liverpool would cease to exist. The Royal Liver Building is reputed to be the inspiration for the Manhattan Municipal Building in New York and the Seven Sisters in Moscow.

2. Cunard Building, Pier Head

Constructed between 1914 and 1917, the Cunard Building was designed by William Edward Willink and Philip Coldwell Thicknesse. It is a combination of Italian Renaissance and Greek Revival styles and was inspired by the grand palaces of Renaissance Italy. It was built by Holland, Hannen & Cubitts with Arthur J. Davis, of Mewes & Davis, acting as consultant.

The building was the headquarters of the Cunard Line, which in 1934 became the Cunard-White Star Line. It incorporated a large booking hall on the ground floor with models of some of the passenger liners that had been conceived, designed and planned in the building, such as the *Queen Mary* and *Queen Elizabeth*. Integrated into the building was space for waiting rooms for first-, second- and third-class passengers, luggage storage rooms and a currency exchange. The basement became an air-raid shelter during the Second World War and was the central Air Raid Precautions headquarters for the city of Liverpool. However, the building ceased to be the headquarters for the Cunard Line when they relocated to Southampton in the 1960s and it was sold to the Prudential Insurance Company in 1969 and the Merseyside Pension Fund in 2001.

The Cunard War Memorial is located on the river side of the building and was erected in memory of Cunard employees who lost their lives during the First and Second World Wars. It is a Grade I-listed monument designed by Arthur Davis and was erected in 1920; it was unveiled by Edward Stanley, the 15th Earl of Derby, in 1921. The building includes a

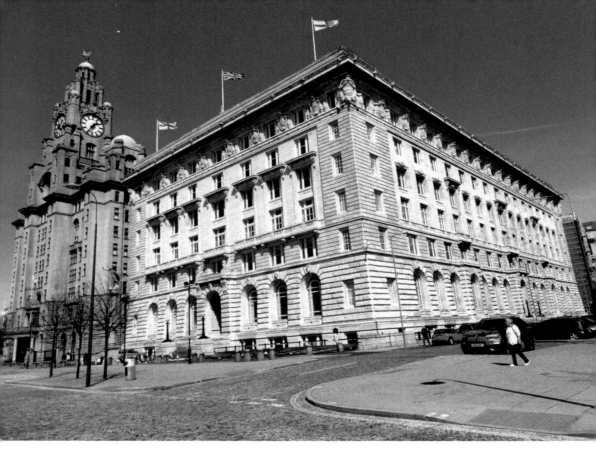

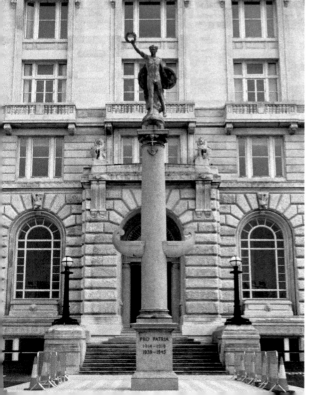

Above: The Cunard Building, Pier Head.

Left: The Cunard War Memorial.

bronze statue sitting on top of a Doric-style column that was sculptured by Henry Pagem, with John Stubbs & Sons responsible for the stonework. The figure of a man standing on the prow of a ship was designed to represent victory. The inscription reads '*pro patria*', which means 'for one's country'. There are also a number of other memorials at the Pier Head: the Merchant Navy War Memorial, the memorial to the Engine Room Heroes of the *Titanic*, the Alfred Jones Memorial, the King Edward VII Memorial, the Johnnie Walker and the memorial remembering all the Chinese merchant seamen who served and died in the First and Second World Wars.

3. Port of Liverpool Building, Pier Head

The water was run out of George's Dock in 1900 and Sir Arnold Thornley and F. B. Hobbs were given the job of designing a headquarters building for the Mersey Docks and Harbour Board. Work on the 'dock offices' began in 1904 and the build was completed in 1907 at the cost of £350,000. It was built with a reinforced concrete frame, is clad in Portland stone and was designed in an Edwardian baroque style with a large dome on the top. The fact that it was built using reinforced concrete meant that it was not only structurally strong but it was also more fire-resistant than other buildings. As it was built on the site of the old dock, the foundations were required to be deeper than normal and the use of over 35,000 tons of cement was necessary.

The Port of Liverpool Building was built next to the river so asphalt was used to coat the floors and walls of the basement to ensure that it was waterproof. The building was

The 'Three Graces' at the Pier Head.

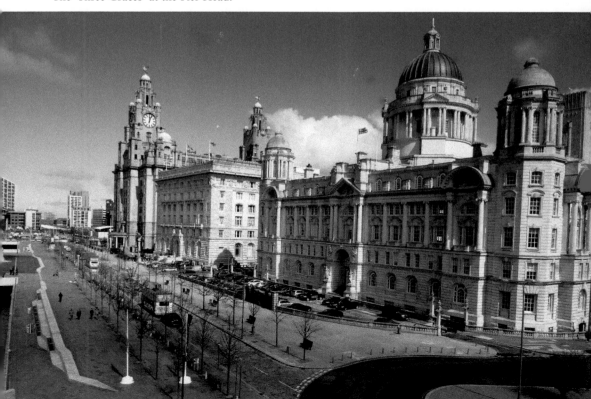

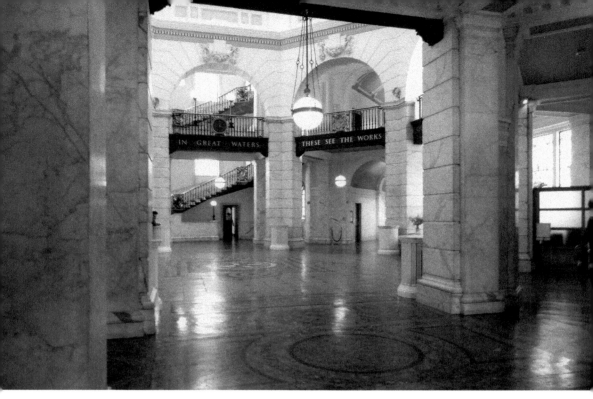

The ground floor and central lobby of the Port of Liverpool Building.

made with Spanish mahogany and Danzig oak, with bronze for the furniture and fittings and white marble for the floors and walls. The grey-granite grand staircase is lined with stained-glass windows with images of Poseidon. There is a globe at the entrance, supported by dolphins, and the cast-iron gates are decorated with mermaids, anchors and shells.

During the Blitz of May 1941, a bomb exploded in the basement on the eastern side, causing extensive damage to the building, however the rest of the building was soon in use and the damage was repaired at the end of the war. It was the headquarters of the Mersey Docks and Harbour Board for eighty-seven years (1907–94) until the company relocated to smaller offices at Seaforth Dock near the main container berths. The building was sold to a property developer and between 2006 and 2009 over £10 million was spent on restoring most of its original features.

4. Museum of Liverpool, Pier Head

The new Museum of Liverpool at the Pier Head is part of the National Museums of Liverpool group. The building was opened on 19 July 2011, replacing the former Museum of Liverpool Life, and was built to reflect the city's global significance through its unique geography, history and culture. It is situated in a new purpose-built structure at Mann Island.

The story of Liverpool life is told through collections of costumes and decorative art, entomological and botanical collections and objects representing social and economic history, archaeological items and photographic images. The city of Liverpool's cultural diversity and migration is reflected in a series of displays in the large gallery space. Visitors

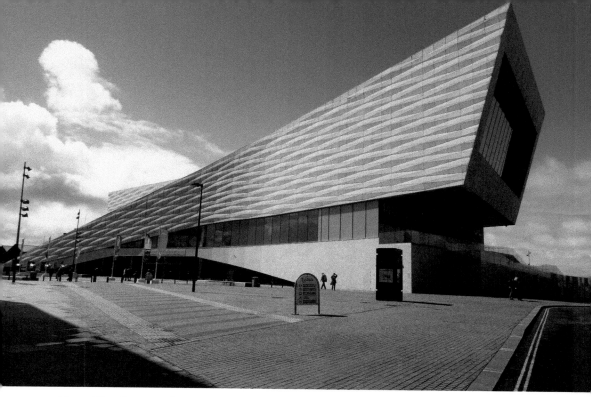

Above: The Museum of Liverpool at the Pier Head.

Below: A coach from the Liverpool Overhead Railway at the Museum of Liverpool.

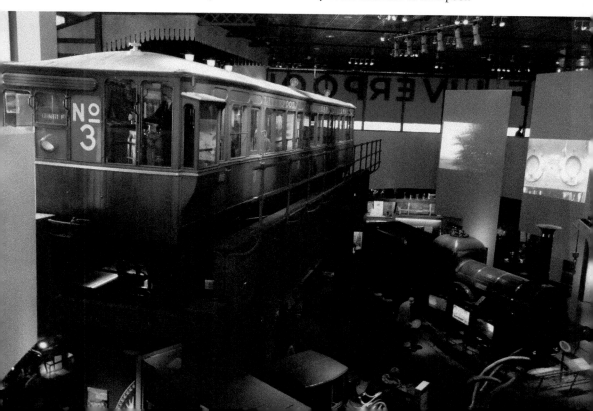

are able to explore how the port, its people, their creativity and sporting history have shaped the development of the city. The galleries include City Soldiers, Global City, History Detectives, Little Liverpool, Liverpool Overhead Railway, Skylight Gallery, the People's Republic, and the Wondrous Place. There is a room from the old Liverpool Sailors' Home, a crush barrier from the Anfield Kop and a Ford Anglia built at the car plant at Halewood. The steam locomotive *Lion* was moved by road on 27 February 2007 from Manchester to Liverpool and is now located in the museum. Little Liverpool, a gallery for young children, History Detectives, an interactive archaeology and history resource centre, and a 180-seat theatre are also part of the museum.

5. Riverside Station, Princes Parade

At the Pier Head, the station was opened on 12 June 1895 and was used to allow passengers to travel to the ocean liners by rail. It had two main platforms of 795 feet and 698 feet with a centre release track between them and a 560-foot bay platform covered by a roof. Beyond the buffers were waiting rooms and an inspector's office.

It was accessed via the Victoria and Waterloo tunnels and was used during the Second World War, transporting troops from across the country when it suffered bomb damage – this was repaired in 1945. The passengers embarked from the liner by a sheltered way to the customs examination rooms and, after the luggage had been passed, walked forward, still under cover, to the waiting express train. This passed over a network of lines about the dock system and entered the tunnel which emerged at Edge Hill on the main line.

The site of Riverside Station in 2016.

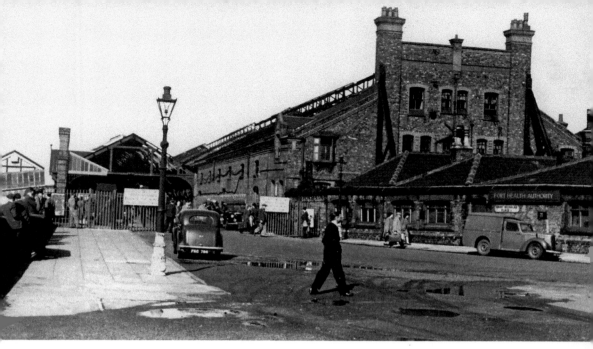

Riverside Railway Station at Princes Parade.

The station was closed between 21 October 1949 and 27 March 1950 when the Belfast Steamship vessel *Ulster Queen* collided with, and damaged, the swing bridge at the entrance to Princes Dock. On 20 September 1960, the English Electric locomotives D211 and D212 were renamed *Mauretania* and *Aureol* respectively at the station. The last train to use the station was a troop train carrying soldiers bound for Belfast on 25 February 1971 and it was demolished in the 1990s.

6. Albert Dock

Albert Dock was designed by Jesse Hartley and Philip Hardwick and was opened in 1846 by Prince Albert. This was the first time that a member of the royal family had made a state visit to the city. The warehouse complex was the first structure in Britain to be built out of cast iron, stone and brick with no wood included in the building. Goods were loaded and unloaded directly to the warehouses and items such as brandy, tobacco, ivory cotton, silk, tea and sugar were kept in the secure stores. The dock was not completed until 1847. A new Dock Office was constructed the following year and the first hydraulic cargo handling hoist system was installed.

However, at the beginning of the twentieth century, sail was beginning to give way to steam and vessels were becoming larger and longer. The entrance to the dock was restricting the number of ships it could accommodate and the lack of quay space was a problem in regard to the loading and unloading of cargo.

At the beginning of the Second World War, Albert Dock was used as a base for vessels in the Atlantic Campaign and it was extensively damaged in German bombing raids. After the war, the dock was ignored by the port authority and it received little repair or maintenance, however, the importance of the structure was recognised in 1952 when it was granted

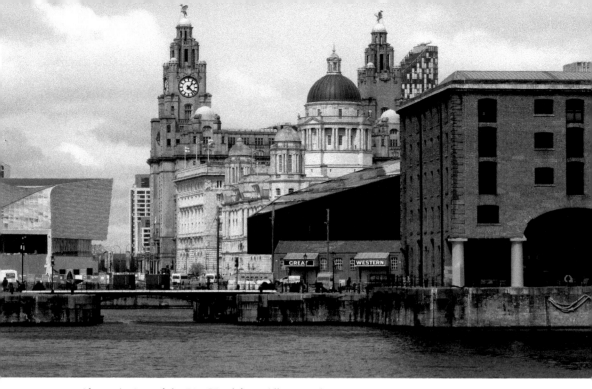

Above: A view of the Pier Head from Albert Dock.

Below: Albert Dock, Edward Pavilion.

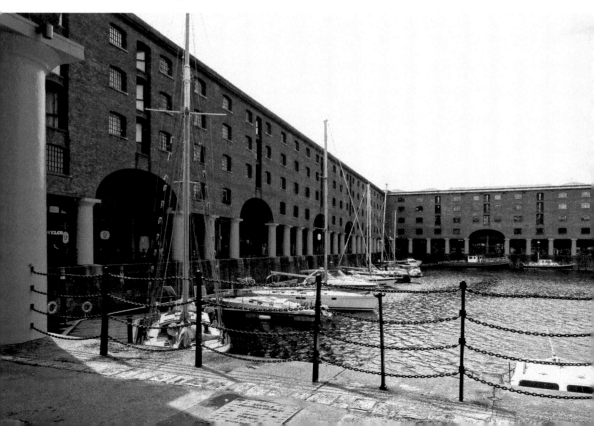

Grade I-listed building status. Several failed plans followed in an attempt to use the dock and take advantage of its heritage and historical value.

Following the financial crisis involving the Mersey Docks and Harbour Board, the dock was closed in 1972 and lay idle until the creation of the Merseyside Development Corporation in 1981. This organisation was made responsible for the regeneration of the south docks system that had been closed by the Dock Company in the 1970s. In 1983 Arrowcroft and the Merseyside Development Corporation signed a contract creating the Albert Dock Company. The main pavilions were renovated in time for the 1984 Cutty Sark tall ships race, which attracted over a million visitors to the city and to the Albert Dock complex.

The Merseyside Maritime Museum opened at the dock in 1986 and Albert Dock was officially opened by Prince Charles two years later. The opening of the Tate Liverpool followed and since then The Beatles Story museum, a hotel and various call centres are now based at Albert Dock. It is the most popular tourist attraction in Liverpool and the most visited attraction in the British Isles outside of London, attracting over four million visitors a year.

7. Dock Traffic Office, Albert Dock

The Dock Traffic Office at Albert Dock was built in 1847 and was designed by Philip Hardwick. The top storey of the building was added by Jesse Hartley. It is built of brick with red-sandstone dressings and has prominent battered chimney stacks with connecting

The Dock Traffic Office at Albert Dock.

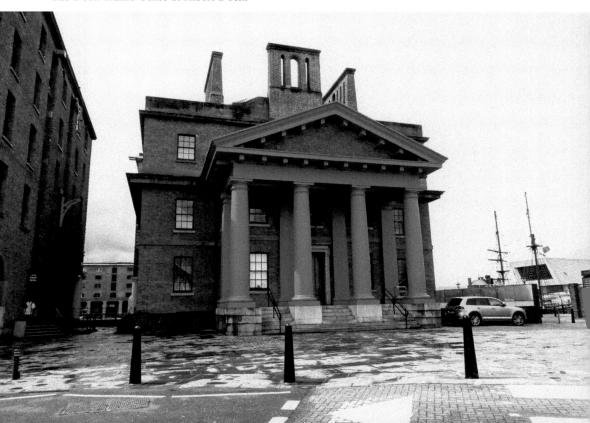

arches. There is a cast-iron Tuscan portico and frieze with four columns, which are 3.5 metres high with a diameter of 1 metre at the base and were cast in two halves and brazed together along their length.

In 1984, after many years of neglect, the building was restored and was used as television news studios for a short time by Granada Television. Four years later, a new national morning television show, *This Morning*, introduced by Richard Madeley and Judy Finnigan, also started to broadcast on weekdays from other studios at the Albert Dock. *This Morning* moved to London in 1996 and in March 2003 it was announced that Granada would close its base at the Dock Office as a cost-cutting measure following its merger with the Carlton Group.

8. George's Dock Ventilation and Control Station

The George's Dock Ventilation and Control Station contains offices and 3-metre-diameter blade fans that extract and force air back to ventilate the Birkenhead Queensway Tunnel. It is Portland stone faced and has sculptures by Edmund C. Thompson, assisted by George T. Capstick. The building was built in art deco style, symbolising the motor car in 1931–34 and was designed by Herbert J. Rowse with engineers Sir Basil Mott and J. A. Brodie.

Above the main doors there is a 7-foot-high relief sculpture named *Speed – The Modern Mercury* and fluted niches to either side of the entrance house the black basalt statues

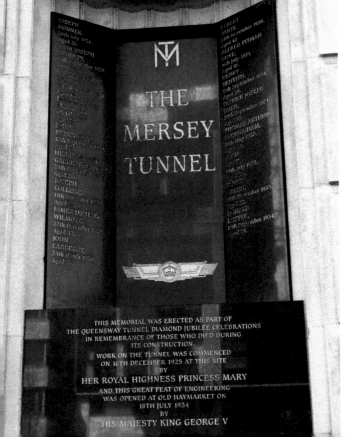

Mersey Tunnel Memorial.

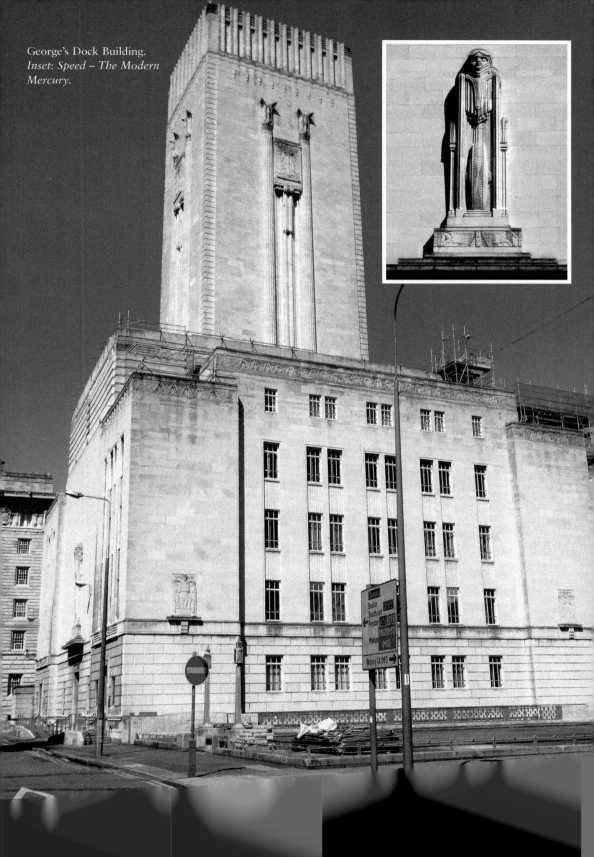

George's Dock Building.
*Inset: Speed – The Modern
Mercury.*

Day and *Night*, symbolising the 24-hour operation of the tunnel. There are further reliefs on the south side, including two goddesses armed with pneumatic jack hammers and a memorial to those who lost their lives during the construction of the tunnel. The building was damaged by a landmine during the Second World War and was repaired in 1951–52 when it was reconstructed to its original post-war condition.

9. Waterloo Dock Warehouse

The warehouses at Waterloo Dock are almost identical to those at Albert Dock. Waterloo Dock warehouse now incorporates approximately 114 apartments. Located close to the Pier Head, this warehouse conversion retains much of its original features with its exposed brick, original cast-iron supporting columns, full-length windows and vaulted, barrelled ceilings. The dock was designed by Jesse Hartley and was opened in 1834. An observatory was opened at the dock in 1844, but by 1867 the pollution was so bad in Liverpool city centre that it was decided to move the chronometer to Bidston Hill at Birkenhead.

In 1868, the dock was divided into East and West Docks and the grain warehouses were built, which were the first in the country to use mechanical handling equipment. Waterloo Dock was closed to shipping in 1988 and the entrance from the Mersey was filled in. However, in 2007 work commenced on a £20 million extension of the Leeds and Liverpool Canal to provide an additional 1.4 miles of navigable waterway through Princes Half Tide Dock. A 6.5-metre channel from Trafalgar Dock to West Waterloo Dock was excavated to provide the link past the Pier Head and through to the Albert Dock.

Waterloo Dock warehouses.

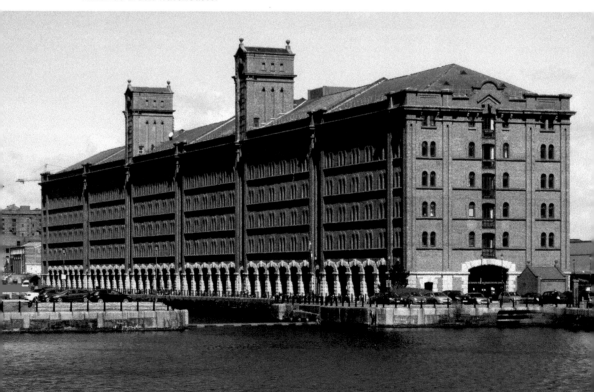

10. Custom House, Old Dock

The Custom House was built between 1828 and 1839 and was designed by John Foster on the site of the Old Dock. It incorporated a post office, a telegraph office and offices for the Mersey Docks and Harbour Board. It was reported that

> people gasped as the knight in shining armour came galloping into view, waving a sword as his horse pranced over the cobbles. This was the king's champion who had been summoned to make a traditional appearance to celebrate King George IV's birthday on 12 August 1828. The day was marked by the construction of Liverpool's new Custom House. After the mayor, Thomas Colley Porter, laid the foundation stone, there were boat races and a band.
>
> *Liverpool Echo*

The Custom House was the port's fifth and the sandstone structure took eleven years to build. There was a warren of alleys and narrow streets around the Custom House and these were demolished to make way for the new Law Courts and the Canning Place development.
On the *Streets of Liverpool* website, the area was described in the 1930s:

> The large stone flags are so unevenly placed and at night time when the passage is dimly illuminated by flickering yellow light from a gas lamp, one has the feeling of passing down the alleyway of an old sailing ship, and the little doorways, resembling those of ships' cabins, serve to accentuate the impression.

A visit to the area in the 1950s was like stepping back to a long-lost Victorian era and it is sad that it could not have been saved from demolition. The Custom House was bombed on

The Custom House on the Old Dock.

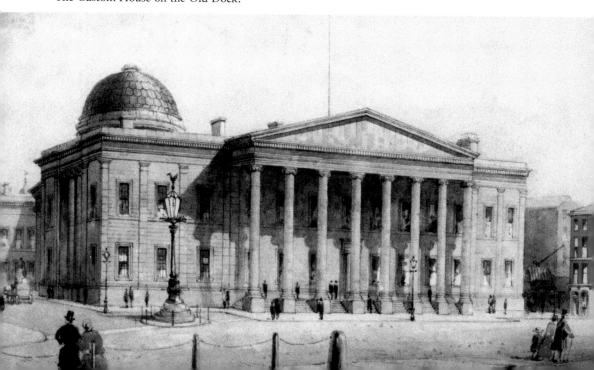

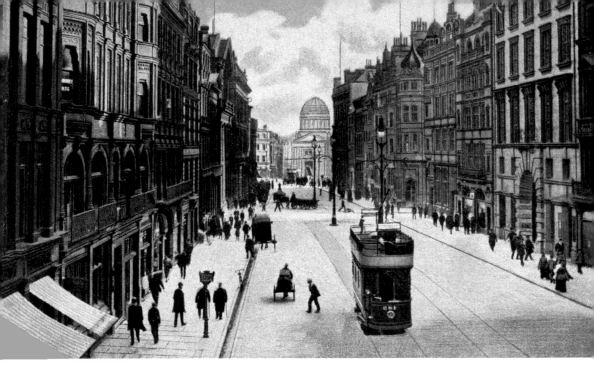

The Custom House from the Town Hall.

3–4 May 1941 during the Blitz and the decision to demolish the building was one of the most contested actions made by the city council. It has been argued that the restoration of the building would have heralded the revival of the city at the end of the Second World War, however, following protests by many groups, the building was demolished in 1948. It was situated opposite the entrance to Albert Dock and now forms part of the Liverpool One development.

11. Albion House, James Street

Albion House was built in 1898 for Ismay, Imrie & Co., otherwise known as the White Star Line, and is a Grade II-listed building. The building was designed by Norman Shaw and J. Francis Doyle. It is situated at the corner of The Strand and James Street and is constructed from white Portland stone and red brick, similar to the former New Scotland Yard building in London. The tall chimneys and angle turrets emphasise the height of the building.

During the Second World War, the main gable, which was crowned with a complicated aedicule, was damaged but was repaired several years later in a simpler design. A large clock projecting from the south-west turret was removed at the same time. The entrance to the building incorporates a large mosaic of South America set into the floor and has a wooden war memorial to those staff who lost their lives in the First World War. After several years of dereliction, the building was purchased in 2014 and converted to a luxury themed hotel at a cost of £5.5 million. The caretaker's flat in the attic has been converted into a rooftop champagne bar called the Carpathia Bar and Restaurant. The bar and restaurant overlooks The Strand and gives views of the river. Each room has a specific theme linked to the history of the White Star Line and their ships.

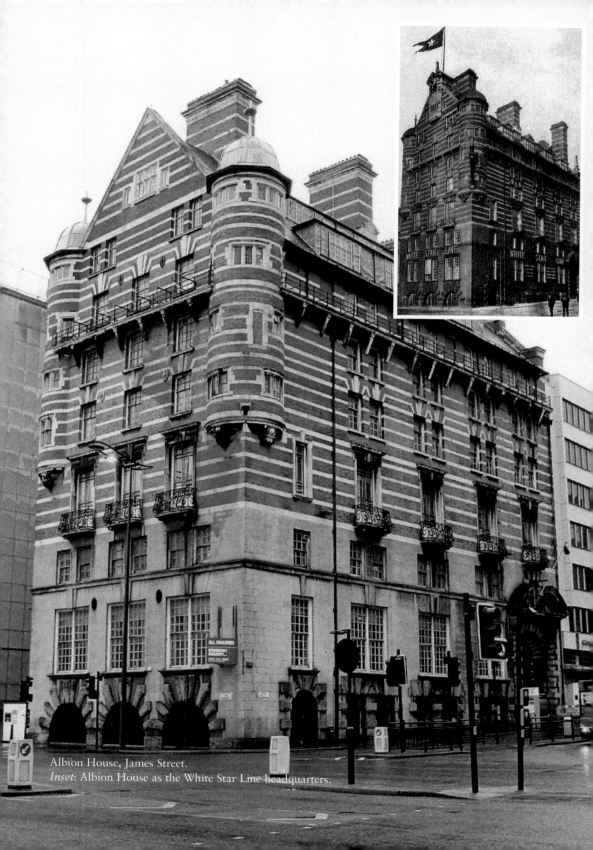

Albion House, James Street.
Inset: Albion House as the White Star Line headquarters.

12. Church of Our Lady and St Nicholas, Chapel Street

George's Dock was opened in 1771. The dock, together with the adjoining George's Basin, was filled in, creating the Pier Head. The Church of Our Lady and St Nicholas is frequently referred to as the sailor's church. St Mary del Quay was a small place of worship that was built on the site in the middle of the thirteenth century until a new chapel was built nearly 100 years later. This was dedicated to St Mary and St Nicholas and when a plague hit the town in 1361 it was licensed as a burial ground.

The chapel was extended in the fifteenth century and by 1515 the church contained four chantry altars. The church was used to detain prisoners during the Civil War years and, between 1673 and 1718, the building was extended and a spire was added in 1746.

At the beginning of the eighteenth century when Liverpool became an independent parish, St Nicholas's and St Peter's became the parish churches. The church was extended again in 1775. On 11 February 1810, twenty-five people were killed, including seventeen young girls from the Mossfield's Charity School, when the spire of the church collapsed. A new tower, designed by Thomas Harrison of Chester, was built between 1811 and 1815.

The last burials in the graveyard took place in 1849, after which it became a public garden dedicated to James Harrison, whose shipping line office was situated to the rear of the church. A Deed of Faculty was granted in 1892 to allow the laying out of the graveyard as an ornamental ground and a parish centre was built in the 1920s. The church was severely damaged in the Blitz of December 1940 and, following extensive rebuilding, it was consecrated again on 18 October 1952.

Church of Our Lady and St Nicholas at the Pier Head.

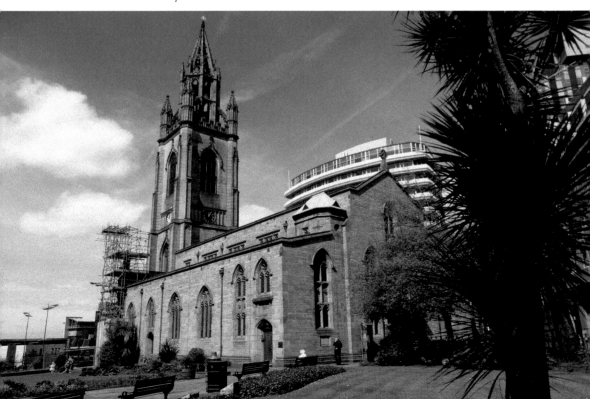

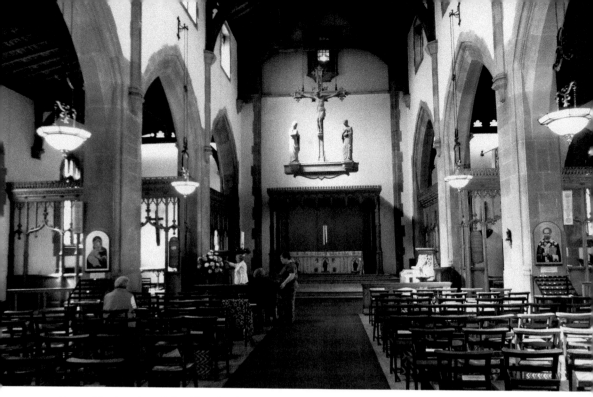

Above: The interior of the Church of Our Lady and St Nicholas.

Below: Our Lady and St Nicholas Church beside the Royal Liver Building.

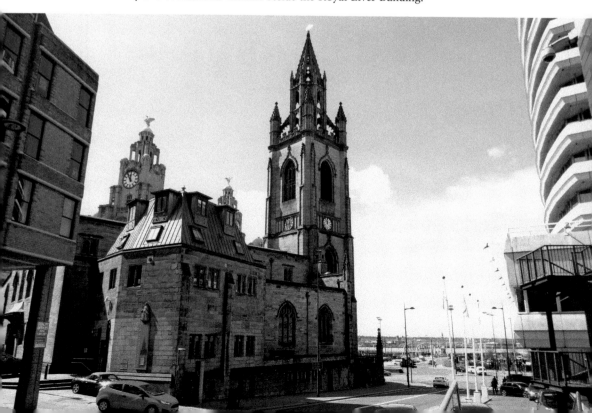

13. Liverpool Town Hall, Castle Street

Designated as a Grade I-listed building, Liverpool Town Hall in Castle Street is the city's third town hall and was designed by John Wood of Bath. The first town hall was replaced in 1673 by a building just south of the present one which stood on pillars and arches of stone. The present town hall was built between 1749 and 1754 and an extension to the north, designed by James Wyatt, was added in 1785. A serious fire severely damaged the hall in 1795 and it was rebuilt with an additional dome; the work was completed in 1802. A central courtyard was replaced with a hall containing a staircase, a portico was added to the south side and the work, including the decoration, was completed by 1820.

In 1775, during a dispute with their employers, who were inside, seamen attacked the building with a cannon and in 1881 there were attempts made to blow up the building. One of the last acts of the American Civil War was when Captain Waddell surrendered his vessel *Shenandoah* at the town hall to the British government in November 1865. In 1881 a plan to destroy the building was made by the Fenians but this was later aborted.

Between 1899 and 1900, the portico on the south face was rebuilt and extended and the northern extension was enlarged to form a recess in the Council Chamber for the Lord Mayor's chair. The ground floor was designed to allow merchants to undertake their business and it now contains the Council Chamber. In 1921 a Hall of Remembrance was made for Liverpool servicemen who died in the First World War.

Liverpool Town Hall, Castle Street.

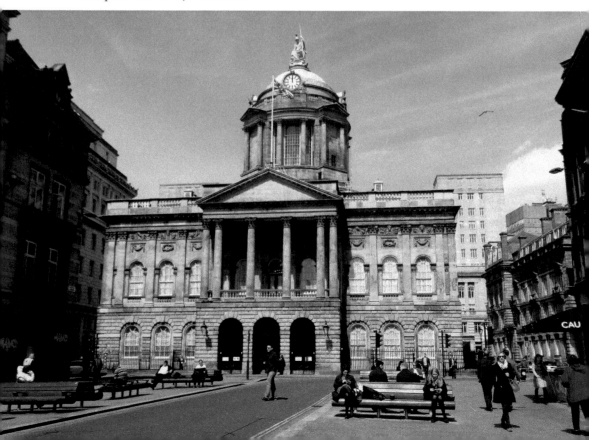

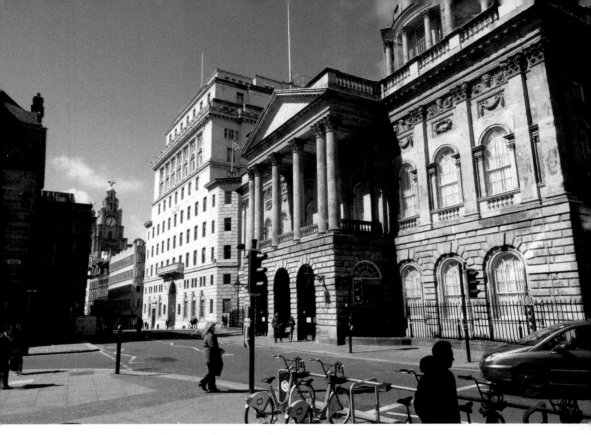

Above: Another view of Liverpool Town Hall.

Below: Liverpool Town Hall and Castle Street.

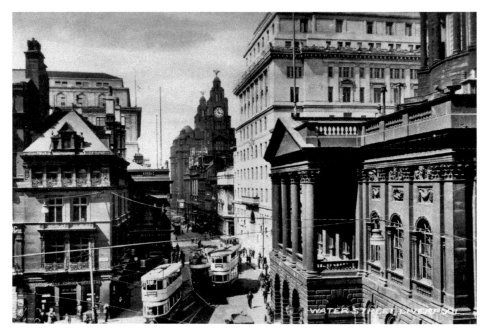

Water Street's electrified transport systems.

Nomination for the Borough of Liverpool in 1868.

The building was also damaged by bombing and air raids during the Second World War. A restoration programme of work was completed in 1995. Exchange Flags is at the back of the town hall and contains the Nelson Monument which was designed by Matthew Cotes Wyatt and sculpted by Richard Westmacott. It was unveiled in 1813. The first building was replaced by a new exchange in 1862, designed by T. H. Wyatt. The present Exchange Flags dates from 1939. Sir Winston Churchill moved the headquarters of the Central Operations from Plymouth to Exchange Flags in 1941. The combined services were able to control the Western Approaches from this centre.

14. Tower Building, Water Street

Tower Building, which was completed in 1908, was designed by W. Aubrey Thomas and is one of the earliest steel framed buildings built in the UK. It is finished with self-cleaning white glazed tiles and large windows to allow the maximum amount of light into the

Tower Building, Water Street.

building. Sir John Stanley built the first tower in 1406 and during the eighteenth century the Tower of Liverpool, between Tower Gardens and Stringers Alley, was the main jail in Liverpool. It was used to house debtors and criminals.

The tower contained seven small underground dungeons, which housed three to five prisoners each, and there was a chapel in one of the rooms. In 1756 during the war with France, the tower was used to house prisoners of that conflict. It became the property of the Corporation of Liverpool in 1775 when they purchased it from Sir Richard Clayton. On the 3 July 1811 all the prisoners were transferred to a new jail in Great Howard Street.

The tower was demolished in 1819 and replaced by warehouses, and by 1856 a second tower building containing offices was built on the site. This building was demolished only fifty years later. The present building was opened in 1910 with the roofs, floors and partition walls formed of reinforced hollow clay bricks. The staircases were constructed on steel joists cantilevered out of the walls and the building is clad in white Doulton terracotta. Tower Building was converted into apartments in 2006, with the two lower floors retained for commercial and retail use. It overlooks the Royal Liver Building, built in 1910, which was also designed by W. Aubrey Thomas.

15. Liverpool Overhead Railway

At the rear of the Royal Liver Building, the railway was the world's first electrically operated overhead railway and ran from Dingle to Seaforth along the Dock Road. It was opened on 4 February 1893 by the Marquis of Salisbury and ran for 6 miles from Alexandra Dock to Herculaneum, with eleven stations along the line. It was extended to Seaforth Sands on 30 April 1894 and to Dingle on 21 December 1896. A northward extension was completed in 1905, which took the line to the tracks to the Lancashire & Yorkshire Railway's North Mersey branch, and this allowed a service to be provided to Aintree Racecourse when the Grand National Race took place.

An elevated railway had been discussed in 1852 and in 1878 the Mersey Docks and Harbour Board gained powers for a single-line steam railway but the proposal was rejected by the Board of Trade. However, in 1888 the Liverpool Overhead Railway was formed to build a double-track railway and Sir Douglas Fox and James Henry Greathead were commissioned to design the project. American electric railways were studied and this method of propulsion was chosen. The railway was built with 16-foot wrought-iron girders and 567 of these were erected, most being 50 feet long.

In 1902, newer and more powerful electric motors were fitted to the trains and the railway was described as 'the best way to see the finest docks in the world'. The railway suffered bomb damage during the Second World War and it was not nationalised in 1948. The Mersey Docks and Harbour Board blocked a proposal to extend the line to join the Lancashire & Yorkshire Railway at Seaforth and maintenance costs continued to rise steeply in the 1950s. Various surveys were carried out, which found that the track and structure were badly corroded and that it would be very expensive to repair the system. Consequently, the Liverpool Overhead Railway went into voluntary liquidation and the line closed on 30 December 1956. Work to completely demolish the line commenced in 1957 and was completed the following year.

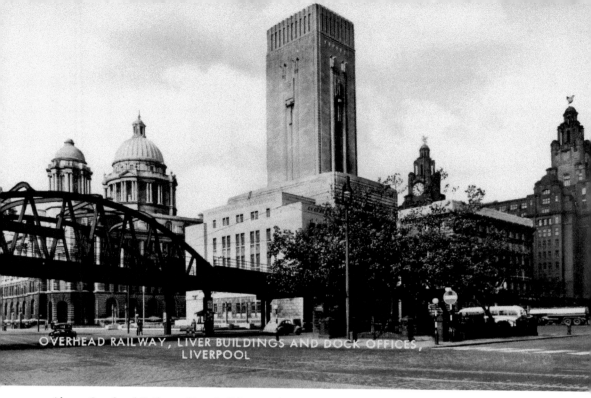

Above: Overhead Railway, Liver Buildings and Dock Offices.

Below: Liverpool Overhead Railway.

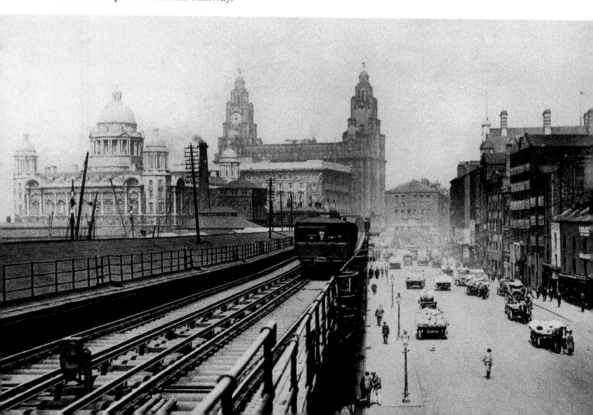

16. Oriel Chambers, Water Street

Oriel Chambers, together with the Jayne Building in Philadelphia, was one of the world's first buildings that featured a metal-framed glass curtain wall. The building comprises 43,000 square feet (4,000 square metres) of floor space over five storeys. It was designed by Peter Ellis who used light by employing a grid of oriel windows and many of the techniques he used were later incorporated into skyscrapers built in America in the 1880s. Nikolaus Pevsner called it 'one of the most remarkable buildings of its date in Europe' and stated that 'the delicacy of the ironwork in the plate-glass oriel windows and the curtain walling at the back with the vertical supports retracted yet visible from outside is almost unbelievably ahead of its time'.

Ellis was also the architect of No. 16 Cook Street which was built two years later. An oriel window is a form of bay window that projects from the main wall of a building but does not reach the ground. They are seen in Arab architecture in the form of mashrabiya. Oriel College, Oxford, took its name from a balcony or oriel window forming a feature of a building that occupied the site.

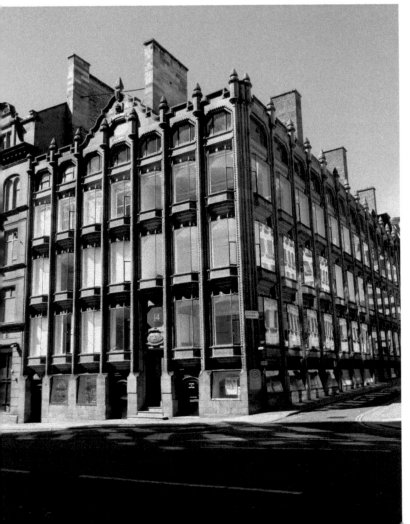

Oriel Chambers on Water Street.

In 1863, a fire destroyed the offices and warehouse at the junction of Water Street and Covent Garden, which was owned by Revd Thomas Anderson. Ellis was commissioned to design the new building to be built on the site and also one at No. 16 Cook Street. *The Builder* magazine of 20 January 1866 described Oriel Chambers as a 'large agglomeration of protruding plate glass bubbles' and a 'vast abortion'.

Ellis moved his office from Orange Court to Oriel Chambers in 1871 and practiced as an architect, valuer, surveyor and civil engineer. He died aged seventy-nine of pneumonia at Falkner Square on 20 October 1884. It is thought that his work influenced the American architect John Wellborn Root who designed the Rookery Building in Chicago where he used a glass and iron spiral staircase similar to that in No. 16 Cook Street, Liverpool.

17. Martins Bank Head Office, Water Street

The Liverpool head office of Martins Bank was opened for business on 24 October 1932 and is a Grade II-listed building designed by Herbert Rowse. Martins Bank was acquired by the Bank of Liverpool in 1918 and it was renamed the Bank of Liverpool and Martins Bank. The name was shortened in 1928 to Martins Bank Ltd with 560 branches.

The Martins Bank building was constructed between 1927 and 1932 and has a steel frame with Portland stone. It is ten storeys high with the upper ones set back. The central entrance leads to a banking hall with island counters and vaulted arcades on four sides. Circular corner lobbies give access to offices which cantilever over the banking hall. There is a boardroom on the eighth floor and penthouses on the roof for lift machinery

A plaque on the ground floor of Martins Bank Building.

IN·MAY·1940·WHEN·THIS·COUNTRY·WAS
THREATENED·WITH·INVASION
PART·OF·THE·NATIONS·GOLD·RESERVE
WAS·BROUGHT·FROM·LONDON
AND·LOWERED·THROUGH·THE·HATCH
FOR·SAFE·KEEPING·IN
THE·VAULTS·OF·MARTINS·BANK

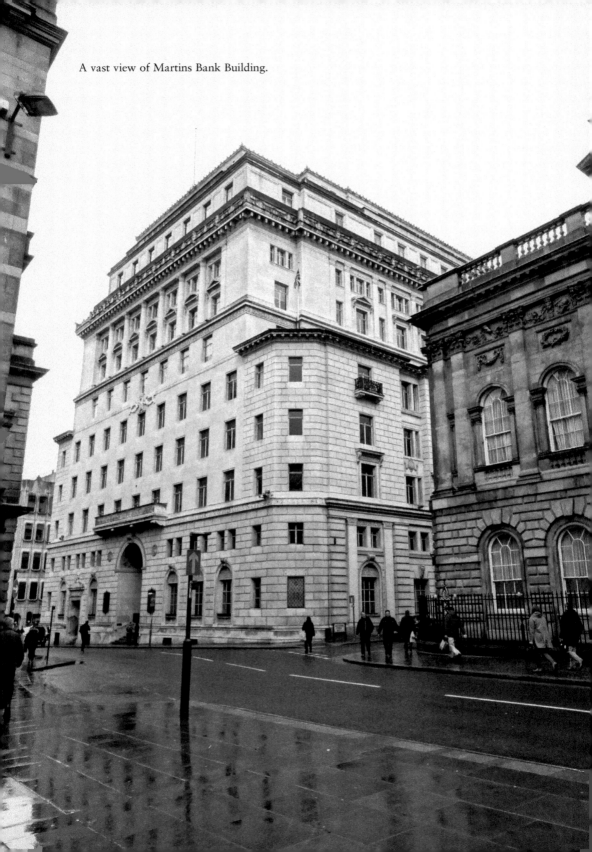

A vast view of Martins Bank Building.

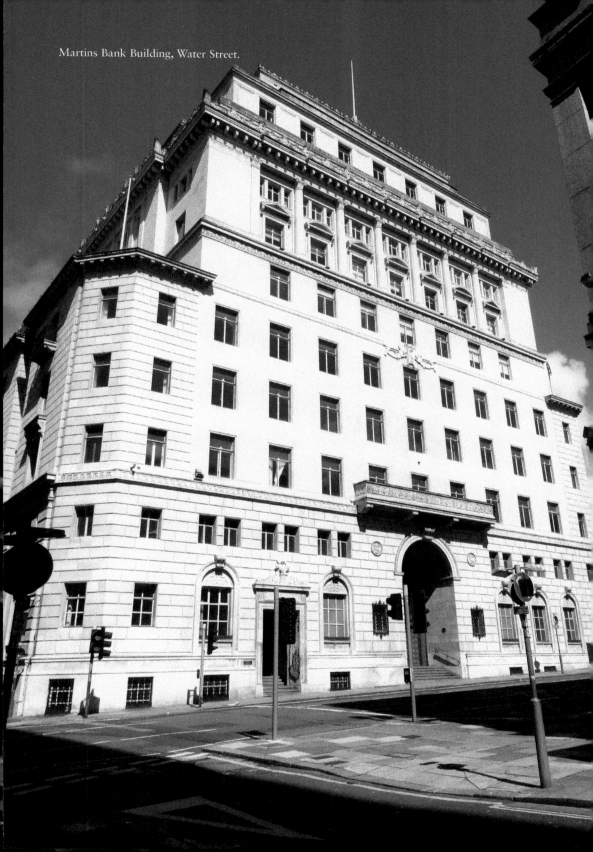

Martins Bank Building, Water Street.

and an apartment. The sculptures inside and outside the building are themed on money and the sea and are by Herbert Tyson Smith, assisted by Edmund Thomson and George Capstick. It is thought that the style of the building was influenced by the Paris Exhibition of 1925.

The bank vaults are in the basement directly below the main banking hall. Shortly after the outbreak of the Second World War, a portion of the gold held by the Bank of England was transferred from London. It was later shipped to Canada. The sub-basement was excavated out of sandstone, containing extensive storerooms and oil tanks for the central heating system, which holds 7,000 gallons. The boiler house is situated under the sub-basement. The building was constructed with reinforced concrete floors, which house an underfloor duct system, concealing power and telephone cables.

Between 1958 and 1967, the bank owned and operated Lewis's Bank, with branches in most of the Lewis's stores and in Selfridges in London. Lewis's Bank was sold to Lloyds Bank in 1967 and the last Lewis's store closed in Liverpool in May 2010. Martins Bank was acquired by Barclays Bank in 1969. The exterior walls were washed down in the 1970s, which dramatically improved the appearance of the building, and the Martins Bank building was sold in 2003 with a temporary leaseback of the banking hall.

18. India Buildings, Water Street

India Buildings was designed by Arnold Thornely and Herbert J. Rowse and was built between 1924 and 1932. It was financed by Alfred Holt & Co. for its own use and to let office space to other businesses. The building was constructed by Dove Brothers of Islington with steelwork from Dorman Long of Middlesbrough and cost £1.25 million. It replaced an older India Building on the site, which was built in 1830 for George Holt.

The second India Buildings was built in two stages, with the first constructed alongside the earlier building and the second stage demolishing and replacing the original. At the planning approval stage it was decided to incorporate an arcade of shops, which would run from the front of the buildings to the back. It was originally occupied by Lloyds Bank, the Post Office, insurance and commercial companies, solicitors and government offices, including an entrance to James Street railway station.

It is built on steel frames, with Portland stone walls and Italian Renaissance detail. Arched entrances in Water Street and Brunswick Street, modelled on those of the Palazzo Strozzi, Florence, open into elevator halls, vaulted and lined with Travertine. The sixth, seventh and eighth floors were occupied by Alfred Holt & Co.

The building was badly damaged during the Second World War in 1941, and was later repaired under the supervision of the architect, Herbert J. Rowse. It has since been used as collateral in a court case and was sold to Green Property in 2009. India Buildings was designated as a Grade II-listed building on 14 March 1975 following a campaign by the Twentieth Century Society; its designation was raised in 2013. The reason given for this were its transatlantic influence reflecting Liverpool's historic links as it 'emulates the most impressive early twentieth century commercial buildings of the United States', particularly those in New York. Other reasons included its architectural interest, influences from the Italian Renaissance and the American Beaux Arts movement, and the eminence of the architects.

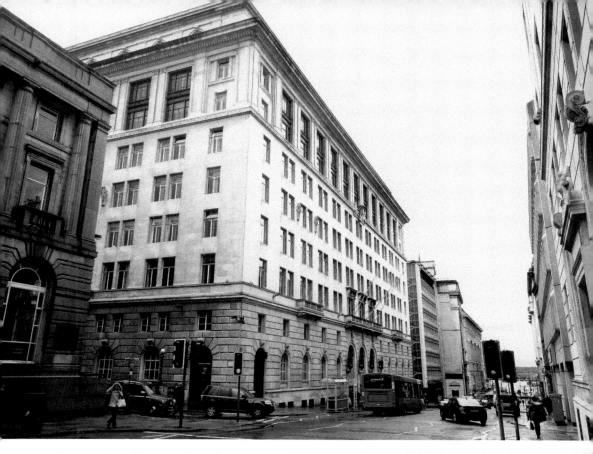

Above: India Buildings on Water Street.

Right: World Heritage plaque and another marking the site of the first India Buildings at the main entrance to India Buildings.

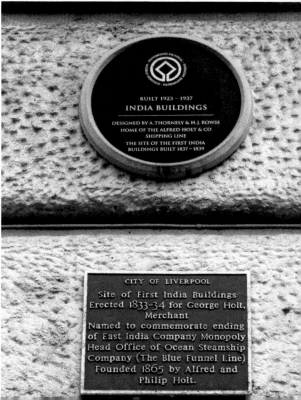

BUILT 1923 - 1937
INDIA BUILDINGS

DESIGNED BY A. THORNELY & H.J. ROWSE
HOME OF THE ALFRED HOLT & CO
SHIPPING LINE
THE SITE OF THE FIRST INDIA
BUILDINGS BUILT 1837 - 1839

CITY OF LIVERPOOL
Site of First India Buildings
Erected 1833-34 for George Holt,
Merchant
Named to commemorate ending
of East India Company Monopoly
Head Office of Ocean Steamship
Company (The Blue Funnel Line)
Founded 1865 by Alfred and
Philip Holt.

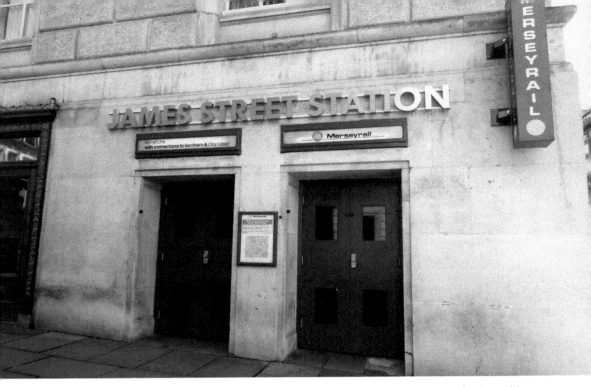

Above: The entrance to Merseyrail's James Street Station on the northern corner of India Buildings.

Below: Large and significant, India Buildings sits modestly among other structures.

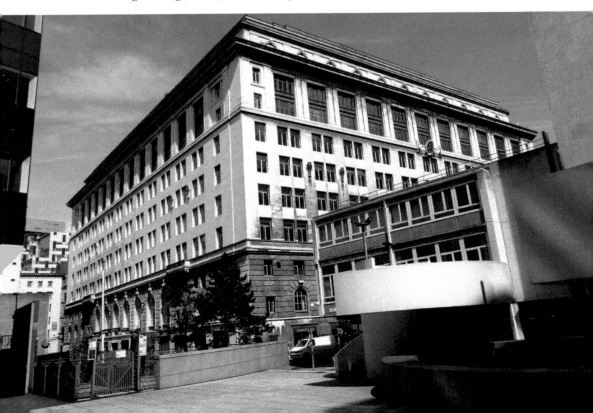

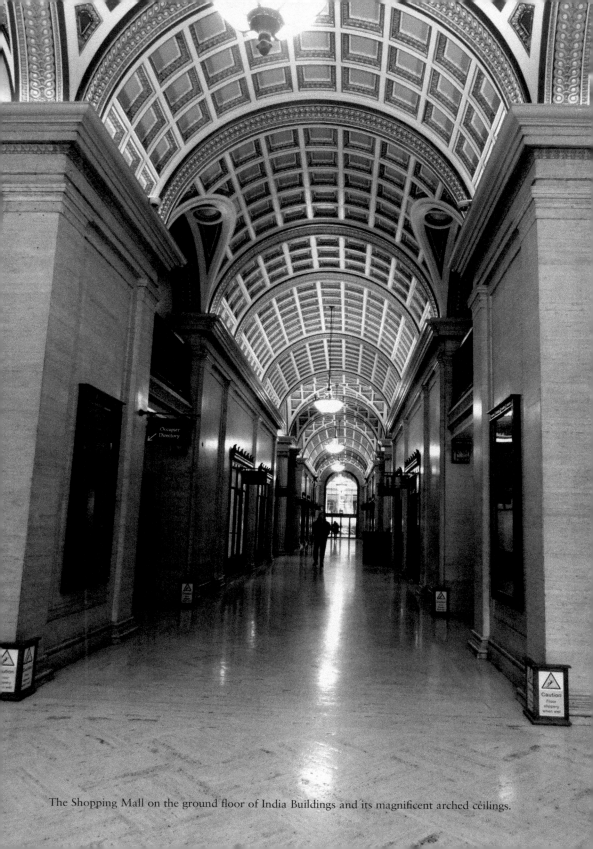

The Shopping Mall on the ground floor of India Buildings and its magnificent arched ceilings.

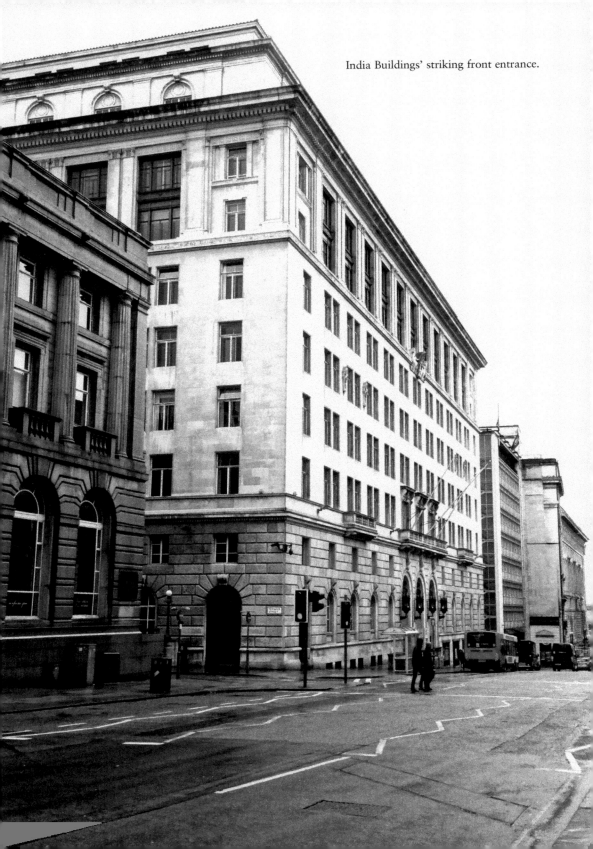

India Buildings' striking front entrance.

19. Bank of England Building, Castle Street

The Bank of England building was designed by Charles Robert Cockerell and was constructed in a neoclassical style between 1845 and 1848. It is situated in Castle Street, which is the heart of the business district with banks, shipping offices and insurance companies, and was built as one of three branches for the Bank of England, combining Greek, Roman and Renaissance styles. It was described by Nikolaus Pevsner as a 'masterpiece of Victorian architecture'.

The front of the building contained the residence of the Bank's Liverpool agent and was entered from Union Court, with the subagent's house entered from Cook Street. At the front of the building are three bays, divided by fluted columns flanked by rusticated corner piers, raised on a rough granite plinth. The first-floor windows to the residential areas have curved balconies with ironwork. Given the fact that it is only three bays wide and seven bays deep, the building's design has been said to give it an overwhelming large and powerful appearance. It is thought to be one of Cockerell's most impressive buildings.

The Bank of England Building in Castle Street.

20. National Westminster Bank, South John Street

On Castle Street looking toward the Victoria Monument the National Westminster Bank, designed by Norman Shaw and completed in 1900 as Parr's Bank, is on the right. The basement is of smooth grey granite with a round arch rusticated entrance. There are bands of grey, green and cream marble and the window surrounds are cornice red terracotta.

The banking hall, which is lit by a shallow central dome, has offices above and is supported by steel trusses. It is in French Renaissance style; the second-floor windows are ogee-headed and cusped, the third-floor windows are narrow and round-headed and fourth-floor windows are round arched. Tall stone chimneys rise from the roof. The Sanctuary Stone in the road surface outside the bank is the mark of the boundary of the old Liverpool Fair, held each year on 25 July and 11 November. In this area for ten days before and after each fair, debtors were able to walk free from arrest providing they were on lawful business.

The main banking hall inside NatWest.

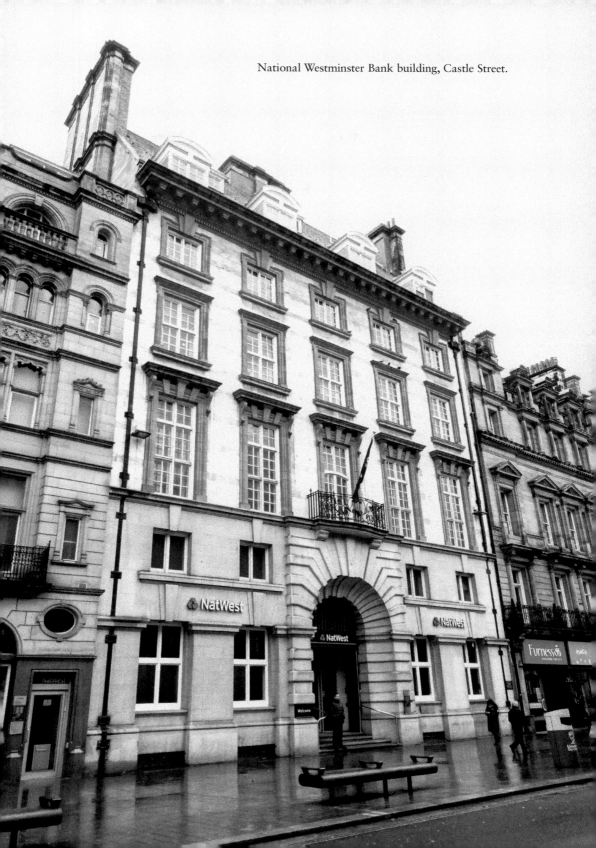

National Westminster Bank building, Castle Street.

21. Cotton Exchange, Old Hall Street

The Cotton Exchange in Old Hall Street was built in 1905–06 and originally had a neoclassical façade with Portland stone columns and twin baroque towers. These were demolished in 1967, but the polished grey columns of Norwegian granite still survive, as do the original side and rear elevations. The sculpture in Old Hall Street represents the River Mersey and two in the courtyard represent navigation and commerce.

The first American cotton to be shipped to Liverpool arrived at the port in 1784. Cotton was imported from Brazil, Egypt and India and by 1850 cotton accounted for almost half of the city's trade. Initially, the cotton merchants met at Exchange Flags to sell and buy the commodity and an exchange was opened in 1808 but the merchants continued to deal in the square until the end of the nineteenth century.

Old Hall Street was formerly named White Acres Street or Peppard Street and the seat of the Moores was originally called More Hall. When the Moores family moved to Bank Hall, they referred to More Hall as the Old Hall, and the street leading to it was then known as Old Hall Street. The International Cotton Association is still based in Liverpool and has offices in Exchange Buildings.

A recent view of the Cotton Exchange.

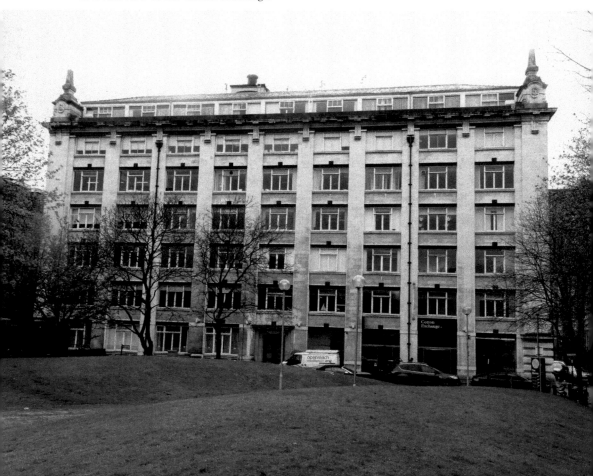

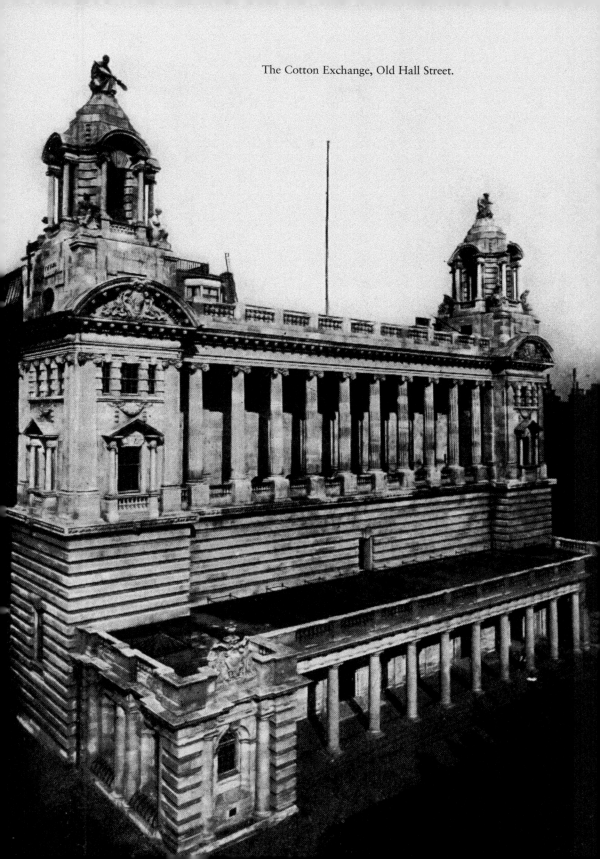

The Cotton Exchange, Old Hall Street.

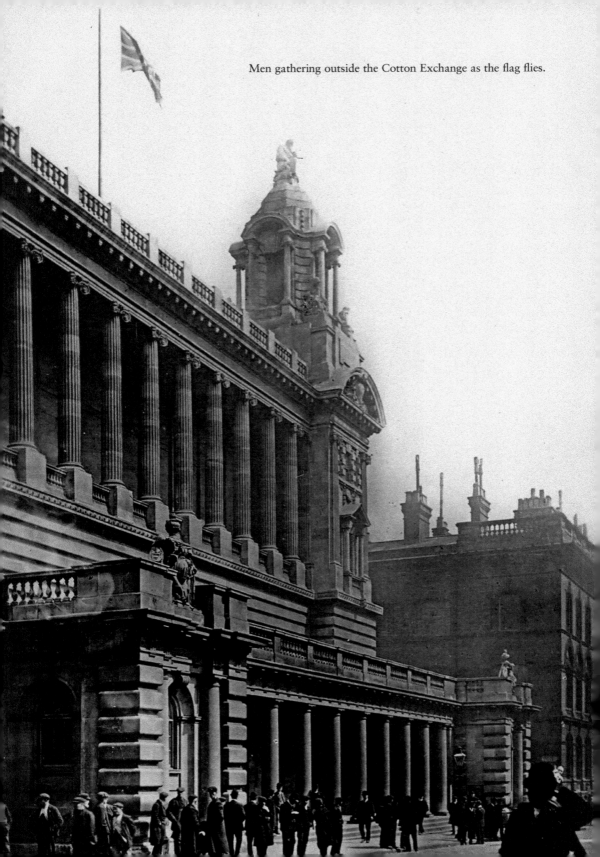

Men gathering outside the Cotton Exchange as the flag flies.

22. Victoria Monument, Derby Square

The Victoria Monument was built of Portland stone in 1901 on the site of St George's Church, which was demolished in 1897. The foundation stone was laid on 11 October 1902 and it was unveiled on 27 September 1906. It is a Grade II-listed structure and was designed by F. M. Simpson, who was the first Professor of Architecture at the University of Liverpool. The four sections around the monument represent agriculture, commerce, education and industry. There are four figures representing justice, wisdom, charity and peace and fame on top of the dome.

St George's Church was built on the site of Liverpool Castle, which operated from 1235 to 1725. By 1347, the castle had four towers and was surrounded by a dry moat. The castle included a chapel, bakehouse, brewhouse, herb garden and an orchard. The parliamentarian John Moore took possession of the castle during the Civil War and Parliament later ordered that the castle be demolished but only parts were taken down. The castle was a ruin by the early 1700s. The monument was surrounded by bombed buildings during the Second World War and the new Crown Court has now been built around it.

The Victoria Monument is made of bronze, is 14 feet in height, and is clad in robes of state beneath a dome supported by four groups of four columns. The dome, surmounted by a figure of Victory, is 56 feet above the pavement.

Victoria Monument in Derby Square.

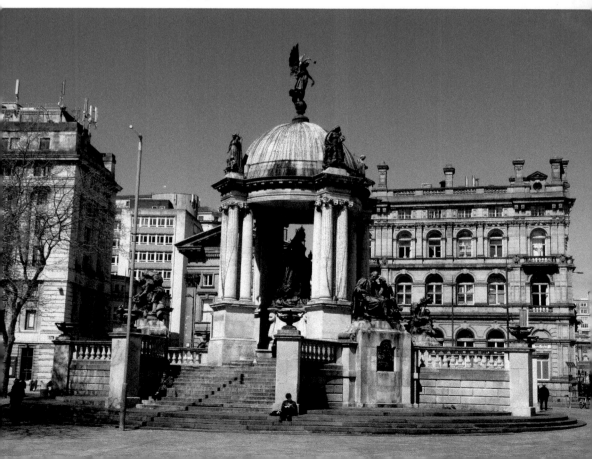

Plaque commemorating the opening of the memorial by HRH Princess Louise in 1906.

DIEU ET MON DROIT

THIS MEMORIAL WAS UNVEILED BY HER ROYAL HIGHNESS PRINCESS LOUISE DUCHESS OF ARGYLL 27TH SEPTEMBER 1906

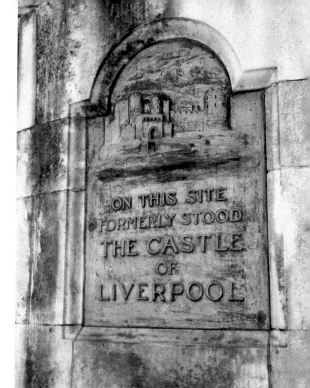

Right: A plaque commemorating the Castle of Liverpool.

Below: Statues gazing down from the Victoria Monument.

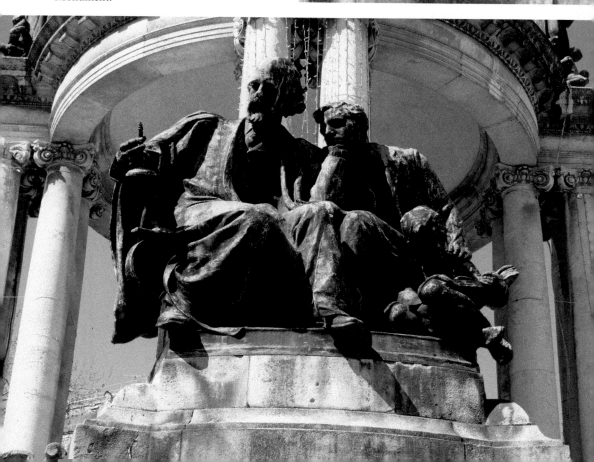

23. Royal Insurance Building, North John Street

The building with the dome in the centre of the picture is the Royal Insurance Building, which is on the corner of Dale Street and North John Street. It was built between 1897 and 1903 and was designed by J. Francis Doyle after a competition shortlist of seven designs. Norman Shaw was retained as the advisory architect as Doyle had worked with Shaw on the White Star building in James Street.

It is built in granite and Portland stone over a steel frame. There is a long facade to North John Street, with an off-centre entrance under a gold domed tower. It features a high and narrow gabled facade with angled turrets in Dale Street. The Portland stone walls are not load-bearing and the floors and chimneys are carried in a steel frame. The original general office occupied the ground floor and is free of columns. There is a sculptured frieze by C. J. Allen, which has an insurance theme, and runs along three sides of the building. The campanile, with an octagonal gilded cupola, is one of the main architectural features of Dale Street, which was originally the main route into the town from Manchester and London. There was a bridge over a brook at the east end of the street and the road was widened in 1786. It was developed with buildings and office accommodation from the middle of the nineteenth century.

The Royal Insurance Building tower.

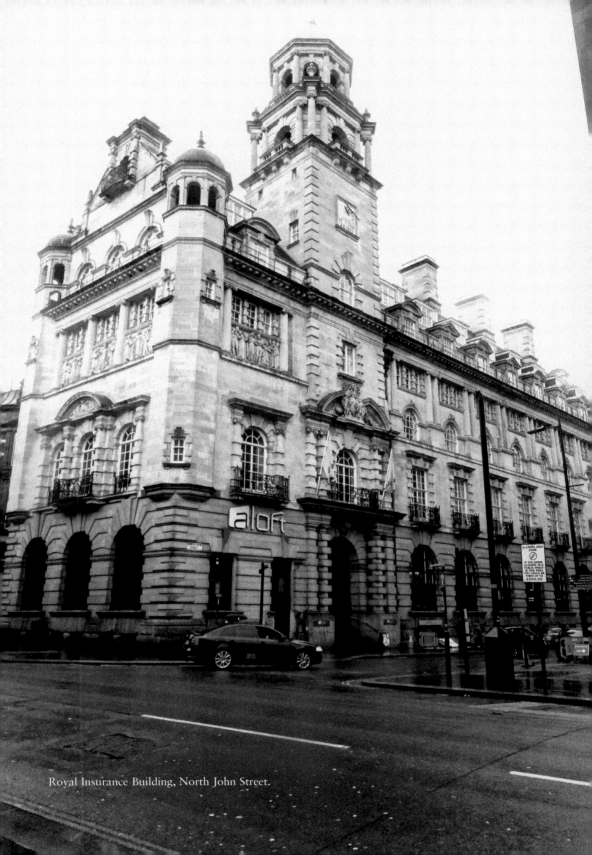

Royal Insurance Building, North John Street.

24. Liverpool, London and Globe Building, Dale Street

The building was built for the Liverpool, London and Globe Insurance Company between 1855 and 1857 and was designed by C. R. Cockerell, his son F. P. Cockerell and Christopher F. Heyward.

The building is constructed in ashlar with rusticated quoins and a slate roof. It is three storeys high with a basement and attics. On Dale Street, there are seven bays and fifteen bays along the sides. The entrance in Dale Street is flanked by red granite Doric columns and the windows on the ground floor have segmental arches and those on the second floor are recessed behind a Corinthian colonnade with balconies. The Mansard roof and dormer windows were added at a later date and it was designated as a Grade II-listed building on 28 June 1952.

The Queen Insurance Building is opposite and was designed by Samuel Rowland for the Royal Bank. This was completed in 1839. It features a grand facade with upper Doric and Ionic columns and a big top balustrade supporting the coat of arms of the Royal Bank. A central passageway leads to Queen Avenue, a street lined with shops and offices. There is also an underground passage which was used during the Second World War as a shelter.

Liverpool, London and Globe Insurance Building and the site of Liverpool's first town hall in 1525–1673.

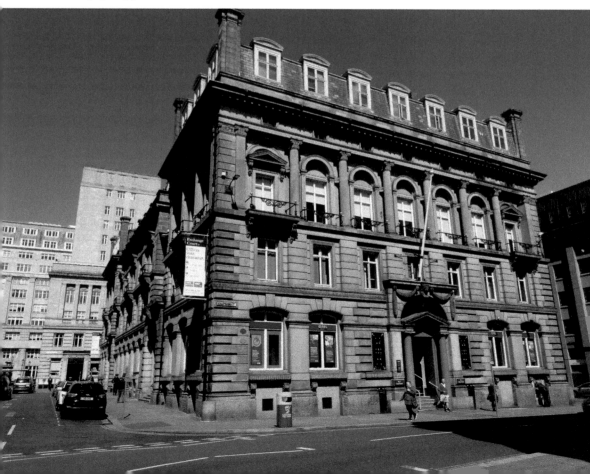

25. Liverpool Exchange Station, Tithebarn Street

Exchange Station was initially opened on 13 May 1850 and it originally had two names. The Lancashire & Yorkshire Railway named it Liverpool Exchange Station and the East Lancashire Railway named it Liverpool Tithebarn Street. It became Liverpool Exchange on 13 August 1859.

From 1 October 1850, Liverpool, Crosby & Southport Railway trains used it as a terminus. As it became inadequate to deal with the traffic, it was rebuilt between 1886 and 1888 and had a grand reopening on 2 July 1888. The station was also the terminal of the Lancashire & Yorkshire Railway, providing services to Manchester Victoria, Blackpool North, the Lake District, Whitehaven, and Glasgow Central. In March 1904, steam was replaced by electric trains on the route to Southport and the route to Ormskirk was electrified in 1911. There were ten platforms under four long roofs, with an access roadway between platforms three and four.

It was reported that the poet Siegfried Sassoon spent time at the hotel adjoining the station and in 1917 he wrote 'A Soldier's Declaration', which was printed in the press. He was visited by Colonel Jones Williams who criticised the poem. The next day, he took the train to Formby and ripped the ribbon off his Military Cross and flung it into the sea.

The station was damaged by bombing during the Second World War and in 1940 an approach bridge was bombed, causing the trains to be diverted; they circled the city via the North Liverpool Extension Line. This service operated from 24 December 1940 until

The front elevation of Liverpool Exchange Station.

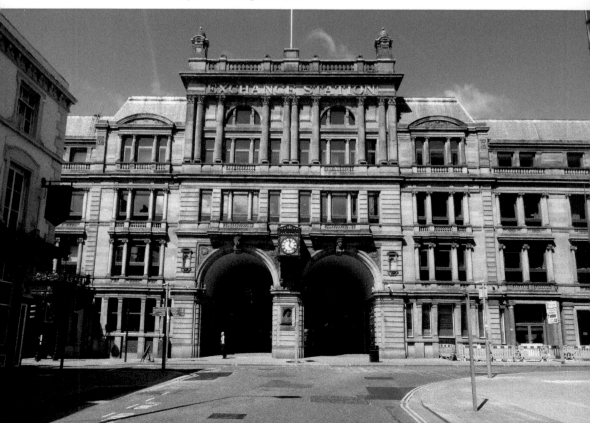

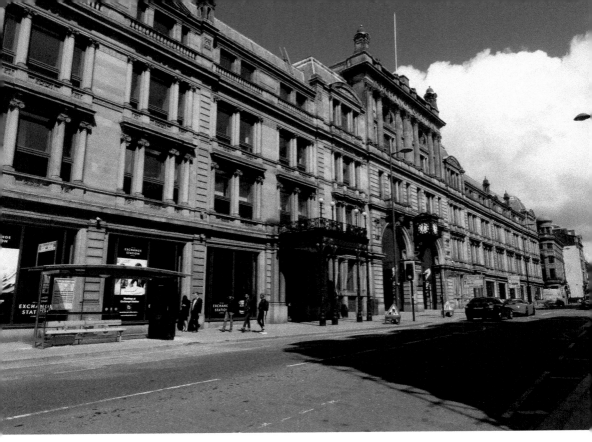

Liverpool Exchange Station.

5 July 1941. On 3 August 1968, the last British Rail scheduled passenger train to be hauled by a standard gauge steam locomotive, Stanier Black 5 No. 45318, completed its journey at Liverpool Exchange. Long-distance services were transferred to Lime Street Station in the 1960s, and in the 1970s the local trains were diverted via a new tunnel to Liverpool Central and the south of the city.

The main station was closed on 30 April 1977 and Moorfields Station opened the following week to provide services by Merseyrail. The station was later demolished, leaving the frontage to be incorporated into a new office building called Mercury Court.

26. General Post Office, Victoria Street

The General Post Office in Victoria Street was constructed between 1894 and 1899 and was designed by Henry Tanner. The building resembled a Loire chateau with a skyline of shaped gables, chimneys and pavilion roofs. The decoration included a sculpture by Edward O. Griffith around the main entrance.

The *Ward Lock Guide Book to Liverpool* describes the post office:

With the exception of St Martin's-le-Grande, London, the Liverpool Post Office is perhaps the largest and most important in the kingdom. In consequence of the great and varied

commercial and shipping interests of the city, and the vast industrial centres in the neighbourhood, millions of letters and newspapers pass through Liverpool Post Office in a single week to all parts of the kingdom and to every portion of the globe.

The main public hall had an inlaid ceiling. Behind the hall, there was a large room in which all of the registered letters were dealt with, to the left was the Inland Sorting Office and to the right of them was the Foreign Sorting Office, both of which extended to the rear of the building. The telegraph instrument room was on the second floor, the Postmaster's Offices were on the first floor, and there was a Telegraph School on the third floor. Pneumatic tubes were fitted from the telegraph department to the various newspapers in the city, and thousands of telegrams were transmitted more rapidly than if carried by messenger.

The General Post Office was open day and night for the transaction of postal and telegraph work. During the Second World War, the upper floors were severely damaged during the Blitz in May 1941, and were removed. The building was owned by the Walton Group and was acquired by Milligan, J. W. Kaempfer and Richardson Developments in 2004 and converted into a 160,000-square-foot shopping centre named the Metquarter, comprising of forty retail outlets. It is now the third largest shopping centre in the city after Liverpool One and the St John's Centre. Metquarter was opened on 9 March 2006 and was sold to Anglo Irish Bank and Alanis Capital in August the following year.

The General Post Office, Victoria Street.

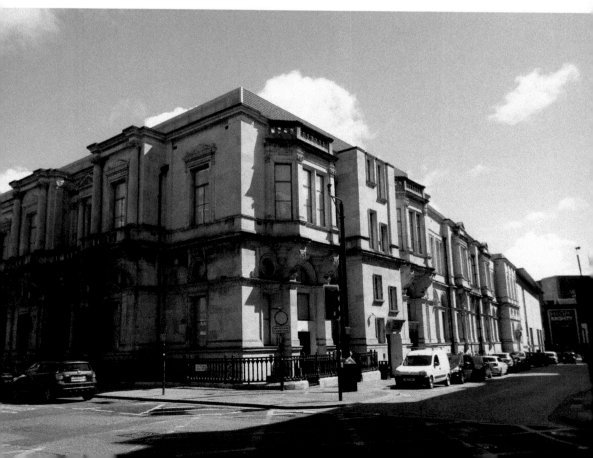

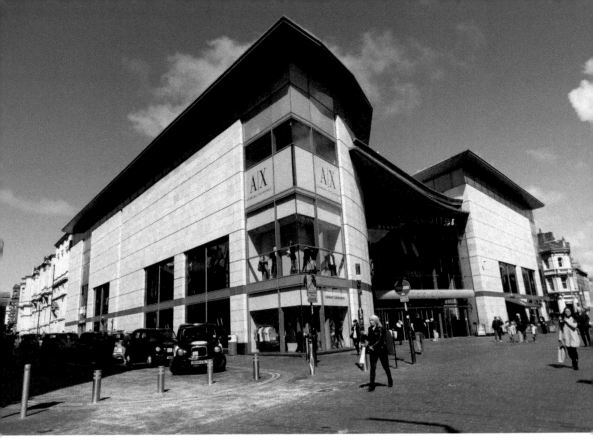

The Metquarter shopping centre.

27. The Tramways Building

At the beginning of the twentieth century, it was intended to build the head office for the trams on reclaimed land at George's Dock. However, Hatton Garden was purchased near the Central Police Station, the Central Fire Station and the Fire Salvage Association. The site was originally owned by John Gordon Houghton, and was bought by the Corporation on 20 July 1904.

The foundation stone for No. 24 Hatton Garden was laid on 12 September 1905 by the Chairman of the Tramways Committee, Sir Charles Petrie and the building was completed in January 1907 at a cost of £48,650. The official opening of the building took place in August that year when the new Chairman of the Tramways Committee, Alderman Fred Smith, received a golden key, the Lord Mayor Richard Caton received a silver rose bowl and the Corporation Surveyor Thomas Shelmerdine a silver cup.

The committees for the Liverpool Corporation Tramways and Liverpool Corporation Electric Supply Department merged in January 1906 and the electric supply department's central staff and cash offices moved into the building. On 30 June 1985, the building was given Grade II-listed status and, on 26 October 1986, public transport was deregulated and it became the headquarters for the Merseyside Passenger Transport Executive, currently named Merseytravel.

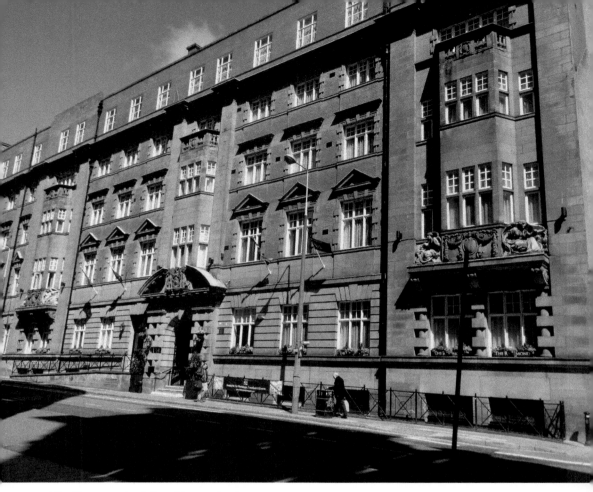

The Tramways Building, Hatton Garden.

28. Magistrates' Court, Dale Street

The Magistrates' Court at the top of Dale Street was built in 1857–59 and designed by John Weightman. The juvenile courts are in the same complex but are accessible from around the corner in Hatton Garden. It is a three-storey ashlar building with a central pediment and carriage entrance below. The Main Bridewell, also designed by Weightman, is behind the Magistrates' Court and is accessible from Cheapside. It is a neoclassical prison building, with the front being separated by a courtyard with gates at the entrance.

The Magistrates' Court is a Grade II-listed building and it was announced in 2007 that they would close and be replaced by new purpose-built facilities. On 23 June 2015, more than 150 years of justice was marked when the Magistrates' Court closed and moved to the Queen Elizabeth II Law Courts in Derby Square. Recorder Clement Goldstone QC, stated that, 'it is an opportunity to show to other court centres how full-time and part-time judiciary can serve together to deliver justice at all levels in a manner which befits the twenty-first century and in an environment which will become the envy of many and aspiration of all'.

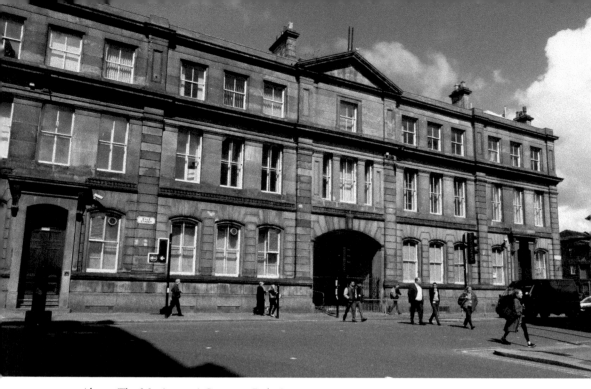

Above: The Magistrates' Court on Dale Street.

Below: The Main Bridewell.

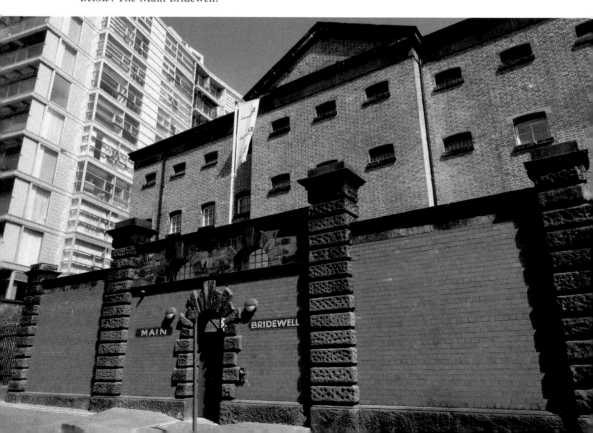

29. Liverpool Blue Coat School, School Lane

The Liverpool Blue Coat School was founded in 1708 by master mariner Bryan Blundell and Revd Robert Styth, the then rector of Liverpool. The Revd Styth organised 'a place where poor children could be accommodated, cared and learn to read, write and cast accounts'. The financial backing was provided by Blundell.

The original building was in School Lane and in 1719 a new building was erected in the Queen Anne style. When Revd Styth died in 1713, Blundell noticed that the poverty of the time was causing the children to neglect their schoolwork and he changed the school into a boarding school, providing food, drink and lodging to the pupils. In 1718, the school was extended and the finance was again provided by Blundell. Bryan Blundell died in 1756 and was succeeded by his son and later his younger brother. A school uniform was introduced which was used by pupils until 1948.

By the end of the nineteenth century, it was clear that a new school building was required and this was completed at Wavertree in 1906. It was then used by the Sandon Studios Society of Arts who held the first exhibition outside London of the artist Claude Monet in 1908. For a short time, the building became the home of Liverpool University's School of Architecture and was purchased by W. H. Lever, the first Lord Leverhulme in 1913, used to promote the arts in the city. It was then acquired by the Bluecoat Society for the Arts in 1927. Bluecoat Chambers was damaged by enemy action during the Second World War and this is commemorated by a plaque, which reads,

Struck down from the sky by the firebrands of the enemy and partly destroyed on
4th May 1941 restored with dutiful affection in the year 1951.

The Bluecoat School.

Another view of the Bluecoat School.

In 1948, the school in Wavertree became a day and boarding school for boys only. Girls were only admitted to the sixth form in 1990 and from September 2002 they were admitted into the school alongside boys following an entrance examination. The Bluecoat Gallery was formed in 1968 and the building in School Lane is now the centre of Liverpool's artistic life. The craft shop at the rear courtyard has metal and glass screens towards College Lane and these were designed by Helen Brown and Gareth Roberts in 1999.

30. St Peter's Church, Church Street

Liverpool became a separate parish from Walton in 1699 and £400 was raised to build a new church that was to be dedicated to St Peter. The church was designed by John Moffat; it was built at a cost of £4000 and was consecrated on 29 June 1704.

Church Street was at one period cut off from Lord Street by saltwater, until the Pool was closed in 1709. It remained unpaved until 1760 and was not flagged until 1816. It was continually in a muddy state and a cattle market was held there once a week.

The first oratorio in Liverpool, *The Messiah*, was performed in St Peter's Church in 1766. By 1767, the town was divided into five wards named St Nicholas, St George, St Peter, St Thomas and St John. In 1831, the church clock was lit by gas for the first time and in 1868 the bodies were moved from the churchyard and reinterred at Anfield Cemetery.

St Peter's Church served as a pro-cathedral from 1880 when Revd Canon J. C. Ryle MA was consecrated the first Bishop of Liverpool on 1 July. On 21 April 1901, a memorial service was held after the funeral of Queen Victoria; the full choral mass was read by Revd H. Clarke and the Bishop of Liverpool announced benediction. It was the largest memorial service ever seen by the people of Liverpool.

Baptisms were held from 1704–1919, marriages from 1804–1919 and burials from 1704–1853. However, the last service took place in the church in September 1919 and the building was demolished in 1922. Work commenced that year on building a new store for Woolworths on the site and this was designed by William Priddle. The building would also accommodate Montague Burton and C&A Modes and it was opened in August 1923. A small brass Maltese cross marks where the church once stood in Church Street.

St Peter's Church on Church Street.

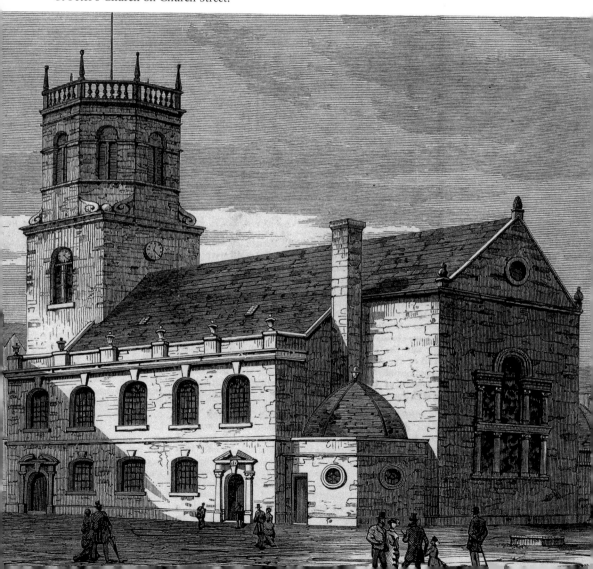

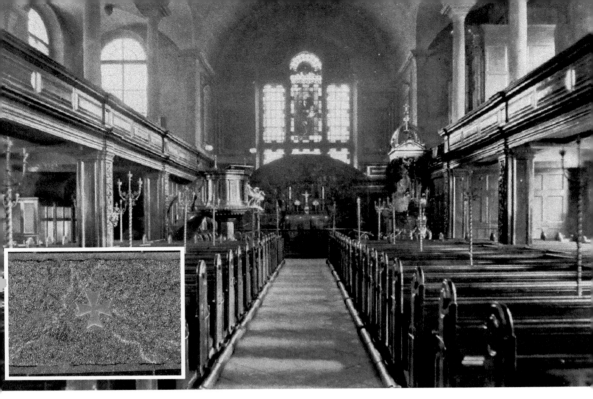

The interior of St Peter's Church.
Inset: The cross in Church Street marking the site of St Peter's Church.

31. The Mersey Tunnel

A tunnel under the River Mersey was first proposed in 1825 and there are reports that the Benedictine monks at Birkenhead Priory had previously found a way of crossing to Liverpool under the river. However, by the 1920s the volume of traffic on the Mersey ferries had increased dramatically and Parliamentary consent was given for the construction of a tunnel between Birkenhead and Liverpool.

Sir Basil Mott was the consulting engineer and he supervised the work in association with John Brodie, city engineer of Liverpool Council. The two pilot tunnels met in 1928 and construction continued with the tunnel entrances, toll booths and ventilation buildings that were designed by Herbert James Rowse. The decoration was by Edmund Thompson and they are now classed as Grade II-listed buildings. Seventeen men lost their lives out of the 1,700 employed on the building of the tunnel. Costing £8 million to build, this was the longest road tunnel in the world until the opening of the Vielha Tunnel in Spain fourteen years later.

The Queensway Tunnel entrance in Liverpool was opened by George V and Queen Mary on 18 July 1934. The tunnel is just over 2 miles long and has two dock branches leading to the dock system on either side of the Mersey. However, the Birkenhead Dock branch was closed to traffic in 1965. In 2004, the Queensway Tunnel was provided with seven emergency refuges at a cost of £9 million. Each has fire-resistant doors, access for wheelchairs, water supply, a toilet, a link to the tunnel police control room and a walkway to the Birkenhead and Liverpool ends of the tunnel.

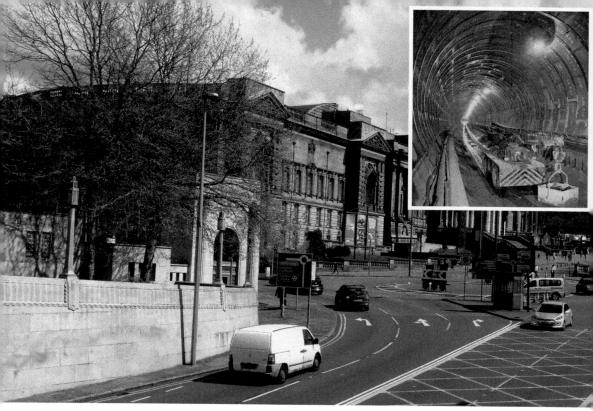

Above: The Mersey Tunnel.
Inset: During the building of the Mersey Tunnel.

Below: The king and queen enter the Queensway Tunnel.

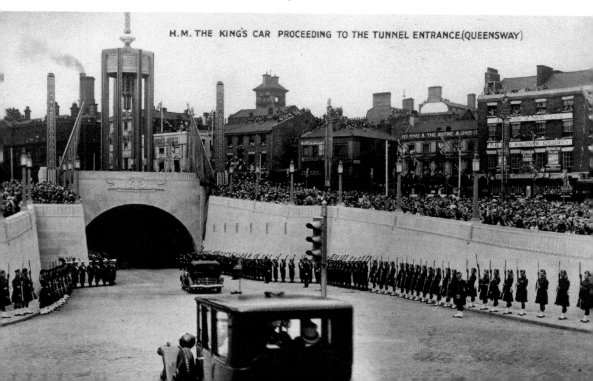

H.M. THE KING'S CAR PROCEEDING TO THE TUNNEL ENTRANCE (QUEENSWAY)

A decision was made to build a two-lane tunnel from Wallasey to Liverpool which was achieved by a large boring machine weighing 350 tons with a 35-foot diameter bit. It was decided that the tunnel would emerge on the Wirral side at Seacombe; a new road infrastructure was required for the increase in traffic. It is just over 2 miles long and contains a carriageway of four lanes, two in each direction. The new tunnel was opened by Elizabeth II on 24 June 1971 and named Kingsway. The Mid-Wirral Motorway, the M53, was built and was finally opened by Lord Leverhulme on 1 February 1972. Initially, the M53 ended at Hooton but an extension to Ellesmere Port was opened in December 1975.

32. St John's Gardens, St John's Lane

St John's Gardens were built on the site of St John's Church, which stood there from 1783 to 1887 and was demolished in 1888. The lane occupied part of what was the 'great heath' of Liverpool that existed until the middle of the eighteenth century. The gardens are enclosed by a massive wall that runs around the 3.25 acres of lawns, trees, flowers and plants. The land sloped upwards and was exposed to the winds, making it ideal for windmills.

Liverpool's first general infirmary was built on the site in 1749 and the Seaman's Hospital three years later, followed by a dispensary in 1778 and an asylum in 1789. As well as windmills, there were rope works, potteries, a marble yard and a row of limekilns. The churchyard contained the graves of many French prisoners of the Napoleonic War who died in captivity in Liverpool. The gardens were laid out by Thomas Shelmerdine who was the city surveyor and were opened in 1904. The garden contains several monuments, including the Gladstone Monument, which was erected in 1904.

A recent view of St John's Gardens.

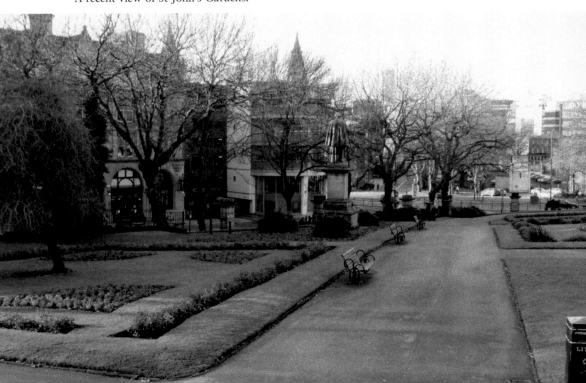

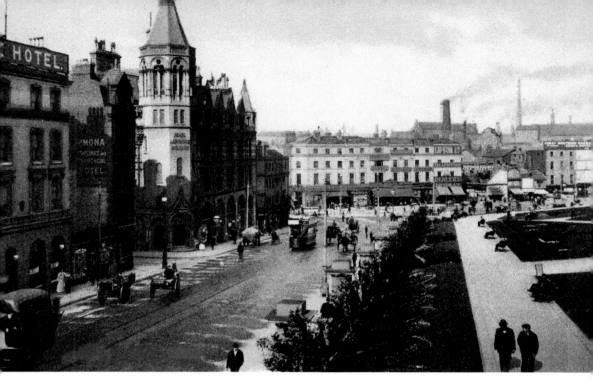

An old image of St John's Gardens.

The Liberal statesman and Prime Minister, William E. Gladstone, was born in Rodney Street in 1809 and died in 1898. The Rathbone Monument was designed by George Frampton and was erected in 1889. William Rathbone was a merchant and philanthropist who was also a Member of Parliament for nearly thirty years. The Forwood Monument was also designed by George Frampton and celebrates the life of the Tory Member of Parliament for Ormskirk who died in 1898. The Balfour Monument, designed by A. Bruce-Joy was erected in 1898 and the Lester Monument, designed by George Frampton, commemorates Canon Major Lester who worked with the city's poor and neglected children. The Nugent Monument was erected in 1906 and the Regimental Monument is of white stone and commemorates the war in South Africa. It was designed by Sir William Goscombe John.

St John's Lane leads past the wall of St John's Gardens and the east side of St George's Hall to Lime Street.

33. William Brown Library and Museum, William Brown Street

The College of Technology and Museum Extension was designed by E. W. Mountford in Edwardian imperial style, with a sculpture by F. W. Pomeroy. The William Brown Library and Museum, which was designed by Thomas Allom opened in 1860, with 400,000 people attending the opening ceremony. It is a Grade II-listed building and was designed in Corinthian style as a replacement for the Derby Museum, which contained the Earl of Derby's natural history collection. The Picton Library, Hornby Library and Oak Room were added later.

The structure is built on Shaw's Brow and the funding was provided by Sir William Brown, 1st Baronet of Astrop. The original design was modified by John Weightman who was the Liverpool Corporation architect. The central lending library issues books to the public and the Commercial Reference Library provides a service to the public and to business and commerce. The museum displayed the 'Mayer Collection', presented by Joseph Mayer, a silversmith formally of Lord Street.

The building was bombed and severely damaged in the Second World War, especially during the air raids of 1941. However, much of the collection had been moved and was later placed on show when the museum was reopened. The library was rebuilt in 1957–60 and was extended to the rear in 1978. The interior of the museum was rebuilt in 1963–69 and, by the end of the century, it was decided to carry out major renovation works to the building.

It was redesigned by National Museums Liverpool and reopened in 2005. However, several years later it was decided to remodel the building and, in 2013, Liverpool Central Library reopened to the public following a £50 million refurbishment that took more than two years to complete. The items on show are the original 1207 charter signed by King John, a valuable copy of *The Birds of America* by naturalist and painter John James Audubon, as well as paintings by the nineteenth-century artist Edward Lear. The refurbishments included the renovation of the facade of the building, the restoration of specialist libraries and reading rooms and the installation of a temperature-controlled repository. The Oak Room is now open to all and a literary pavement leads to the library entrance, displaying the names of writers and titles from the world of books, cinema and music.

A view of the College of Technology and Museum Extension in William Brown Street.

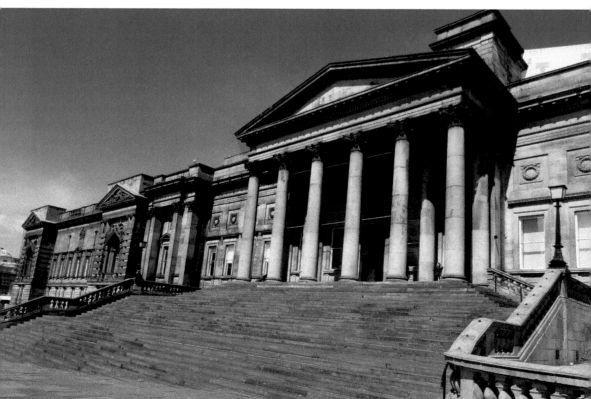

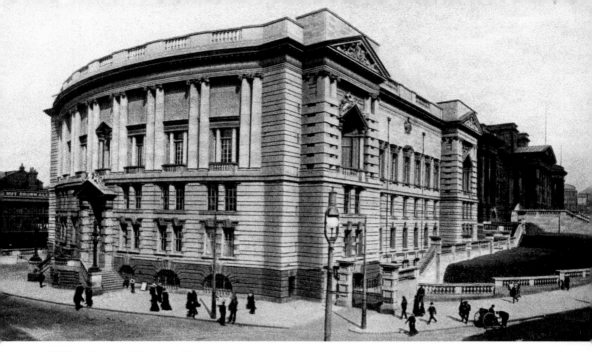

William Brown Library and Museum.

34. Walker Art Gallery, William Brown Street

The Walker Art Gallery was designed by H. H. Vale and was opened in 1877. It was a gift to the city from Sir A. B. Walker, a brewer, during his mayoralty in 1873. Several attempts to organise public subscriptions to build an art gallery failed until Alderman Andrew Barclay Walker became mayor in 1873 and decided he would fund the project.

The building was designed by Sherlock and Vale and was opened in 1877, enlarged due to the addition of nine rooms in 1884 and a further extension that was later built in 1931–33. The gallery is in Corinthian style, the portico consisting of four fluted columns with carved capitals, approached by a flight of steps. On either side are colossal marble statues of Michelangelo and Raphael by John Warrington Wood. The portico is crowned by a figure representing the arts.

The friezes on the building portray a number of scenes: the Duke of Edinburgh laying the foundation stone of the gallery, William III embarking at Hoylake for Ireland in 1690, King John granting the first charter to the burgesses of Liverpool and Queen Victoria in Liverpool in 1851. The figure above the portico represents Liverpool, personified wearing a civic crown wreathed in laurels. She has a ship's propeller in her left hand and a trident in her right.

In 1819, the Liverpool Royal Institution was given a collection of William Roscoe's paintings that were displayed in the gallery. Over the following years, the collection increased as additional work was purchased. The collection at the Walker Art Gallery has included works by Rossetti, Leighton, Holman Hunt, Gilbert Millais, Poynter, Burne-Jones, Calderon, Watts, Rivière, Turner, Richmond and examples from the Liverpool School. In 1957, the gallery revived the tradition of supporting contemporary art with the founding of the biennial John Moores Painting Prize and a major refurbishment of the building took place between 2001 and 2002.

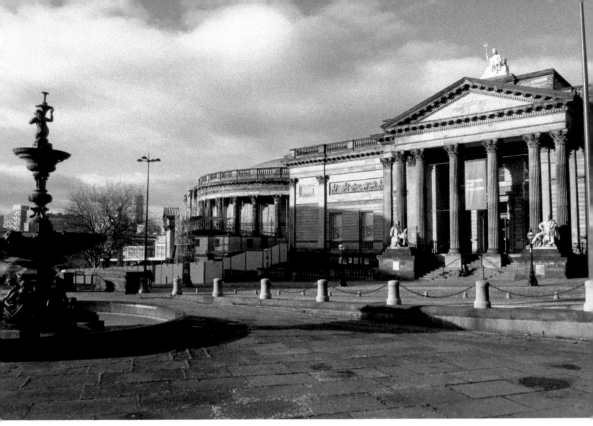

Walker Art Gallery, William Brown Street.

35. County Sessions House, Islington

The County Sessions House was built between 1882 and 1884 for the use of the magistrates of the Kirkdale division of South West Lancashire. The magistrates heard cases involving non-capital offences and the courts compliment the law courts in St George's Hall. It is of composite classic architecture and the principal front has a portico of double columns. It was designed by F & G Holme and houses three courtrooms, attendant facilities, a barrister library and cells. The design was influenced by Renaissance Venice rather than Greece and Rome. Quarter Sessions were abolished by the Courts Act of 1971 and the building is looked after by the National Museums of Liverpool. The front of the building features four paired columns and the crest of Lancashire County Council above the entrance. It is now used as offices for National Museums Liverpool.

The Steble Fountain is in William Brown Street and was designed by W. Cunliffe. It was erected in 1879 and comprises of a circular stone basin with a bronze centrepiece of figures representing the four seasons. It was gifted to the city by Colonel R. F. Steble who was Mayor of Liverpool in 1874/75. It is situated near to the Wellington Column. Commutation Row is to the east of the Steble Fountain and gets its name from an incident in the days of the Window Tax. The residents decided to make their windows as large as possible, leading to a dispute with Inland Revenue. However, a 'commutation' was agreed and the road became Commutation Way.

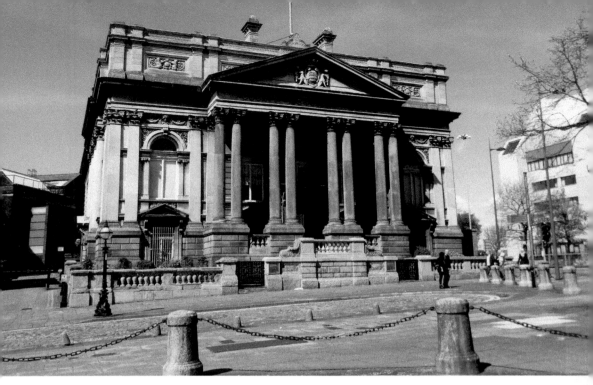

Above: A view of Sessions Court.

Below: Steble Fountain in William Brown Street.

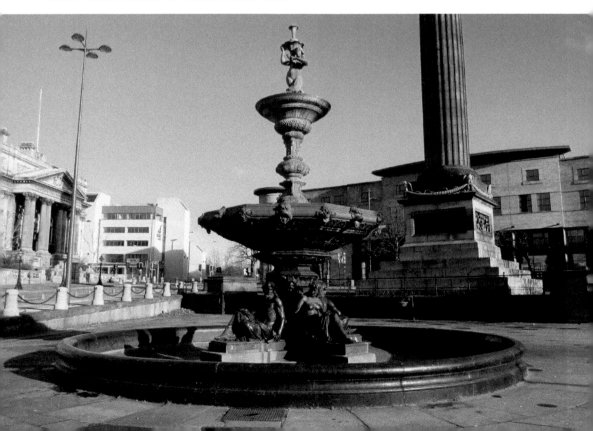

36. Lime Street Station

Lime Street was originally named Limekiln Lane. In the eighteenth century, limekilns stood on the site of the present main-line station. The kilns were demolished after complaints by the doctors of the infirmary across the road regarding the effects of the fumes on their patients.

The opening of the line from Liverpool to Manchester in 1830 formed the beginning of the local railway system. The original terminus of the Liverpool and Manchester Railway was at Crown Street, Edge Hill, just outside the city centre. Lime Street Station was adequate for its purpose when it was built but was soon enlarged with the work necessitating the destruction of streets and the removal and rebuilding of St Simon's Church.

Construction of the new station began in October 1833 when the land was purchased from Liverpool Corporation for £9,000. Prior to the opening of the station, a tunnel was constructed between Edge Hill and Lime Street. Cunningham and Holme were the architects for the project and the station was opened in August 1836 with the work being completed the following year. With each section of the iron and glass double roof having a span of nearly 225 feet, it was completed in 1849 at a cost of £15,000. A further expansion was completed in 1867.

The station is fronted by the North Western Hotel, designed by Alfred Waterhouse in French Renaissance style. Concourse House stood next to the station from 1960 to 2010 until it was demolished as part of a refurbishment scheme. The station provided fast inter-city services to London when the West Coast Main Line was electrified in the 1960s.

Lime Street Station.

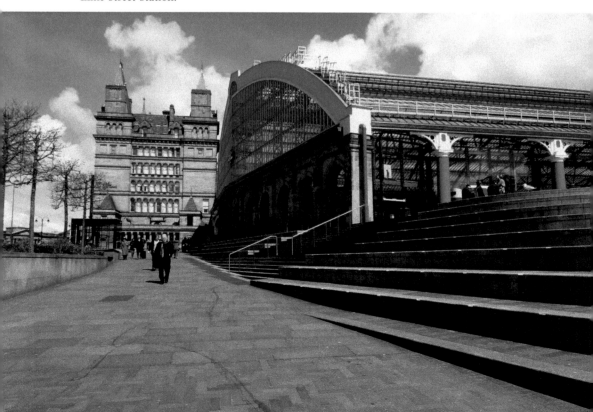

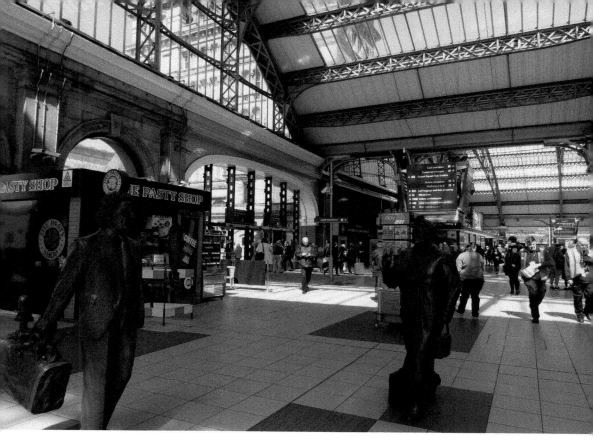

Inside Lime Street Station.

Network Rail has announced that the station will be completely refurbished with new and longer platforms, new lighting, a first-floor concourse for retail units and a row of new ticket barriers. A scheme was previously developed and the shops and buildings in Lime Street at the front of the station were demolished. It is claimed that the new layout helps to direct pedestrians to their destinations, either directly to the main retail area or to the commercial quarter and waterfront. The steps at the higher level are designed to act as a plinth to the station building and also serve as seating. The scheme was named the Lime Street Gateway and aims to allow the heritage assets of the city 'more breathing space' from traffic and also to improve connections in the city centre.

37. St George's Hall, Lime Street

St George's Hall was opened on 18 September 1854 at a cost of £380,000. It was designed by Harvey Lonsdale Elmes and built on the site of the Liverpool Infirmary. A company was formed in 1836 to raise subscriptions for a hall that would be used for festivals, concerts, dinners and meetings. Shares were offered at £25 each and in 1838 the foundation stone was laid to commemorate the coronation of Queen Victoria. Elmes included provision for an assize court in the plans for the building and the work began in 1841. Elmes was only twenty-four years of age when his design was adopted and he died in 1847, aged thirty-three.

In 1851, the work was continued by John Weightman with Robert Rawlinson as the structural engineer and Sir Charles Cockerell appointed as architect.

The main entrance is in the centre of the east façade, approached by a flight of steps where there is a statue of Benjamin Disraeli. The building is 490 feet long and incorporates two courtrooms, a central hall and a concert hall together with ancillary rooms. The hall, built of a grey tinted stone, is raised on a platform with grandly proportioned flights of steps. The general aspect from the south is that of an oblong Corinthian temple with projections east and west. The Lime Street façade forms a colonnade, 200 feet long, with sixteen fluted Corinthian columns. The screen walls have pilasters that become square isolated pillars above the screen and rise to the height of the fluted pillars of the colonnade. The twelve panels between the pilasters have sculptures by Stirling Lee, representing the rise and progress of justice and the relation of the city to industry and commerce. There are four colossal lions in front of the colonnade, each 13 feet long and 6 feet high.

On the steps of the hall is a bronze statue of the Earl of Beaconsfield by C. B. Birch ARA that was unveiled in 1883. Following a visit to Liverpool, the architect Norman Shaw RA wrote:

> I have been all over the Continent and I have certainly seen nothing finer in its way than
> St George's Hall, if as fine. Its simplicity makes it all the more impressive, and while striking

St George's Hall on Lime Street.

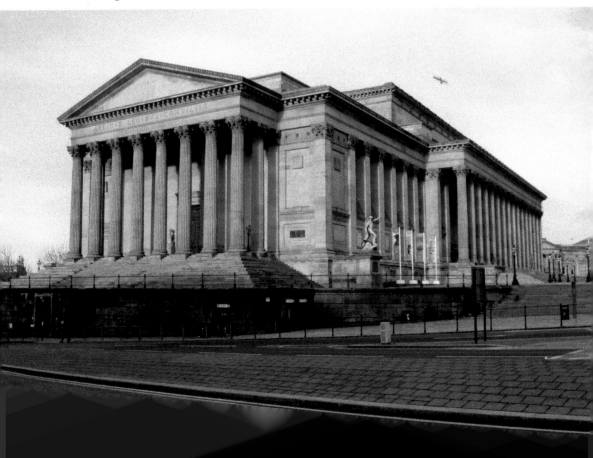

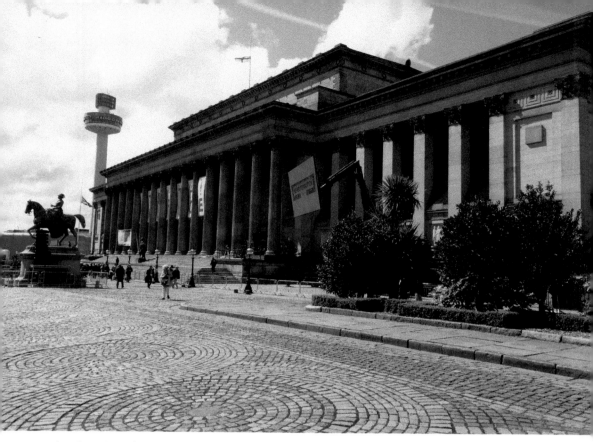

Another view of St George's Hall.

to the eye, the design is full of refinement, and in it we have a building for all time, one of
the great edifices of the world. I look upon it as our finest example of the Greek style.

Costing £23 million, a major restoration of the building took place and it was reopened on
23 April 2007 by the Prince of Wales.

38. North Western Hotel, Lime Street

The former North Western Hotel in Lime Street was opened as a 330-room hotel in 1871.
It was designed by Alfred Waterhouse who was also responsible for the Natural History
Museum in London and the Prudential Building in Dale Street, Liverpool.

The building is built in the French Renaissance style and is faced with Caen and Storton
stone. It has five storeys plus dormers with pavilion-roofed corner towers and two further
towers with short spires flanking the central entrance. The windows are mostly round
arched or with straight tops on quadrant curves. The staircase inside with an open well has
cast iron handrails and leads up to the top floor.

When the hotel was closed down in 1933, the building was empty for a number of years.
It was purchased by the Liverpool John Moores University in 1994 for £6 million and now
provides accommodation for students in 246 apartments.

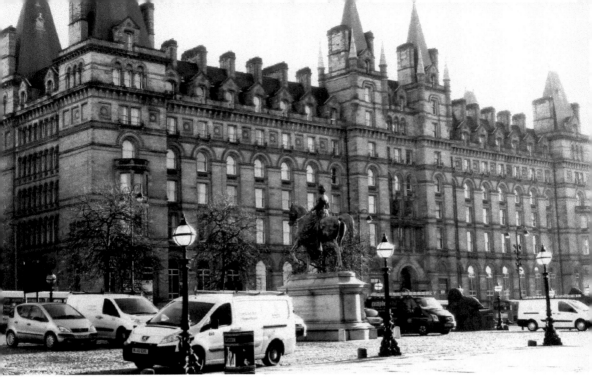

Above: North Western Hotel, Lime Street.

Below: The North Western Hotel, near Lime Street Station.

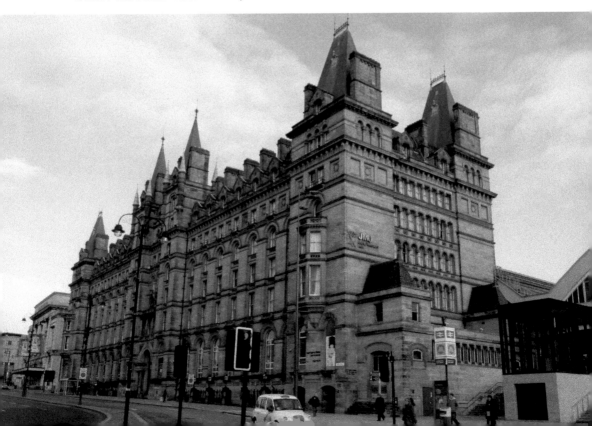

39. Grand Central Hall, Renshaw Street

Opened on 5 December 1905 as the Central Hall, this building was a Wesleyan Methodist church and is now Grade II-listed. It was designed by Bradshaw & Glass of Bolton and built on the site of a Unitarian chapel that dated from 1790 as a memorial to Charles Garrett who died in 1900. The chapel graveyard contained the grave of the historian and philanthropist, William Roscoe.

Central Hall provided seats for 3,576 people: 1,788 in the large hall, 102 in the orchestra, 858 in the stalls and 828 in the balcony. It is built with red brick and yellow terracotta with a domed tower over the corner entrance – some of the further domes are pointed. The structure possesses classical, Byzantine, Gothic and Jacobean styles. The hall also housed the New Century Picture Hall Cinema and, from 1933 to 1939, it was the home of the Liverpool Philharmonic Orchestra while the Philharmonic Hall was being rebuilt. The building was sold in 1990 and in 1997–98 it undertook major restoration work, opening as a nightclub and bar; it has also been used by traders from Quiggins market.

In 2011, The Dome opened inside Central Hall as a 'multipurpose performance space', hosting a variety of events and productions with Victorian theatre seating, ample floor space, a stage, bars, catering facilities, in-house promotions and a range of packages suitable for every event. The facilities are set on two floors, the main hall has seating for 300 people

Grand Central Hall on Renshaw Street.

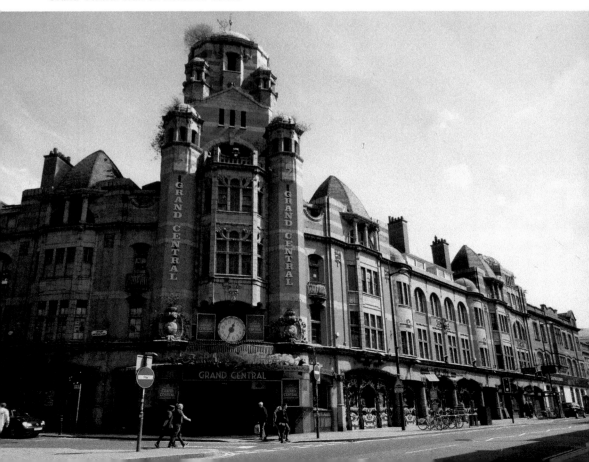

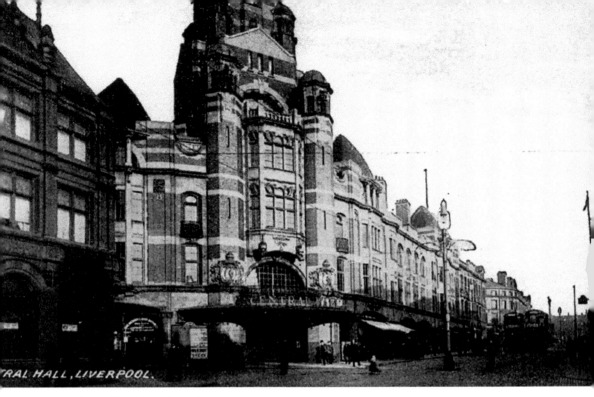

RAL HALL, LIVERPOOL.

Central Hall, Renshaw Street.

and there are two bars. It also has one of England's oldest working organs, dating back to 1904. The balcony has original Victorian theatre seating for 500 people with toilets and two bars. It is hoped that the opening of Central Village between Bold Street and Renshaw Street will help the modern Grand Central Hall benefit from the regeneration of this area of the city centre.

40. Blacklers, Elliot Street and Great Charlotte Street

Blacklers department store was situated on the corner of Elliot Street and Great Charlotte Street. It was founded by Richard Blackler and A. B. Wallis in the early twentieth century. When Richard died in 1919, his wife Margaret became the managing partner and the store became so successful that it employed over 1,000 people at its peak. The building was damaged in May 1941 and the company operated from premises in Church Street and Bold Street.

The store reopened in 1953 and operated until its closure in 1988. Margaret died childless in 1957 and the store passed to her godchild, Vera Kingston, who survived until 1983. Various outlets now operate from the premises and the Wetherspoons public house on the site is named Richard John Blackler in memory of the store's founder.

Blacklers is remembered for its lavish displays, the Winter Wonderland grotto each Christmas and the store's famous rocking horse, Blackie, which was located in the clothing department from the 1950s. When the store closed in 1988, Blackie was donated to Alder Hey Children's Hospital and for many years was the mascot for the hospital's various

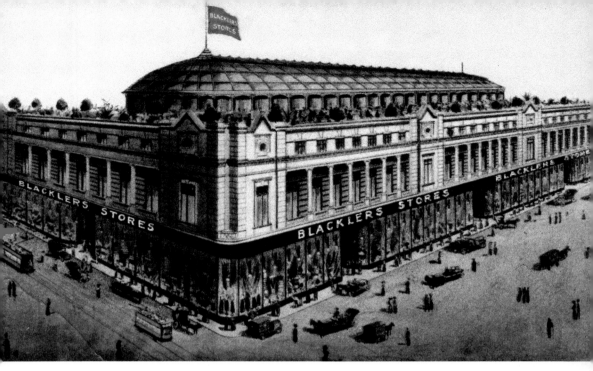

Above: Blacklers Department Store in its heyday.

Below: The former site of Blacklers, now the home of other businesses including Waterstones and a Wetherspoons pub.

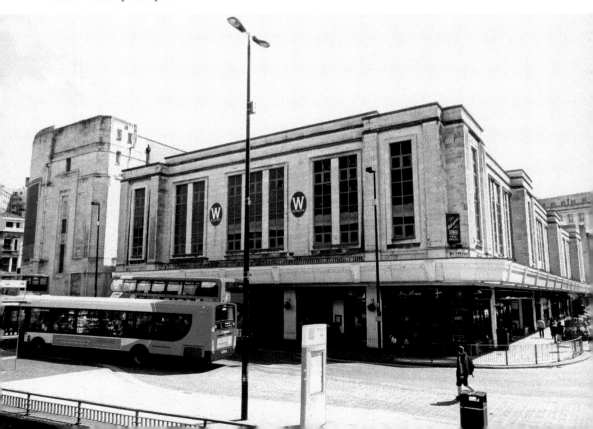

fundraising appeals. Blackie now makes appearances at the Museum of Liverpool Life, together with the 4.5-metre Santa Claus which was on display in the store each Christmas.

41. Lewis's, Ranelagh Street

David Lewis opened his first store in 1856, selling men's and boy's clothing and women's clothing from 1864. He added shoes in 1874 and tobacco in 1879, as well as a Christmas grotto in 1879. A store was opened in Manchester in 1877 and another in Birmingham in 1885. The store in Manchester included a full-scale ballroom on the fifth floor, which was also used for exhibitions.

In 1879, Lewis's in Liverpool opened one of the world's first Christmas grottoes in Lewis's Bonmarché, Church Street – Christmas Fairyland. The store in Sheffield was opened in 1884 but was closed four years later. When Louis Cohen took over the business, new stores were opened in Glasgow, Leeds, Hanley, Leicester and Blackpool. On his death, the control of the business passed to Harold and Rex Cohen.

In 1951, the Lewis Group acquired the famous London departmental store Selfridges and in 1965 became part of the Sears Group headed by Charles Clore. 'Miss Selfridge' fashions were launched in 1966, which later became a separate store chain. However, the company went into administration in 1991 and several stores were purchased by Owen Owen Ltd. The Leicester store traded independently for a short time following a management buyout

A recent image of Lewis's. The store closed in 2010.

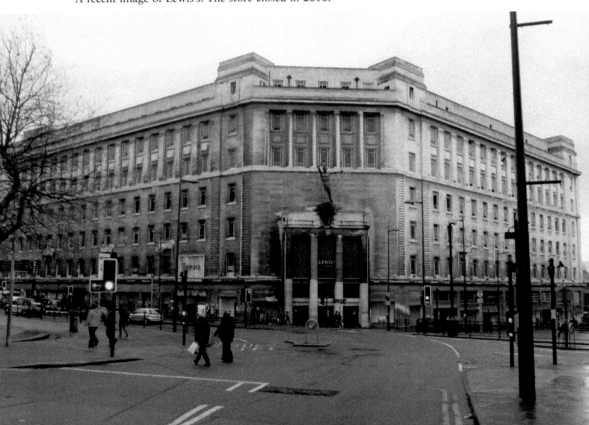

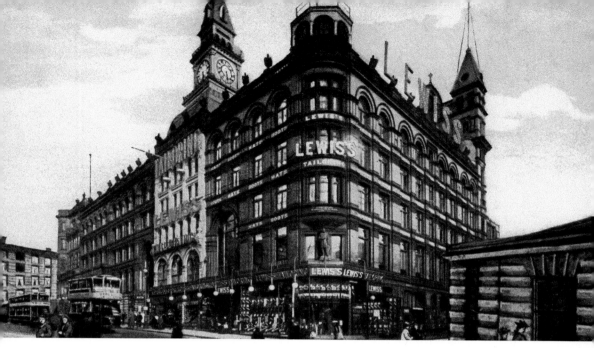

An early image of Lewis's Department Store.

and, after the 1996 Manchester bombing, space was rented to Marks & Spencer and other smaller retailers. The Manchester branch ceased trading in 2002 and the last store to operate was in Liverpool. However, the company went into administration again on 28 February 2007 and the store was sold to Vergo Retail Ltd. This store continued to trade but subsequently closed its doors on 29 May 2010. At the main entrance to the Liverpool store is a statue by Sir Jacob Epstein that was unveiled for Lewis's centenary celebrations in 1956 after restoration work on the war-damaged building was complete.

42. St Peter's Church, Seel Street

St Peter's Church was opened on 7 September 1788 by Revd A. B. McDonald of the Order of St Benedict. The *Liverpool Advertiser* reported that, 'On Sunday last, a new Roman Catholic Chapel in Seel Street, was opened with High Mass, and a sermon by the Revd Mr McDonald.' The first baptisms were performed on the 28 September and the first entry in the baptism book was for Mary, daughter of John and Mary Goosse.

On 1 April 1789, a perpetual lease was granted by the Corporation 'to Father McDonald and successors of the site of St Peter's Chapel, so long as a place of worship'. Father McDonald died on 29 July 1814 and the founder's monument is inscribed, 'In the vaults of this chapel are deposited the remains of the Rev Archibald McDonald. The founder of this chapel, and for 26 years its liberal, intelligent and revered pastor.'

Between 1817 and 1818, the church was enlarged and St Peter's School was opened in Seel Street. The church was extended again in 1845 and in 1847 Irish immigrants landed in Liverpool to escape the famine. At a vestry meeting on 8 June, it was reported that the 57,701 cases of typhus had been dealt with, compared to 420 cases the previous year. On 26 May 1847, Father Appleton died of typhus fever while administering the sick.

Above: St Peter's Church was converted to the Alma de Cuba restaurant.

Below: Inside the restaurant on Seel Street.

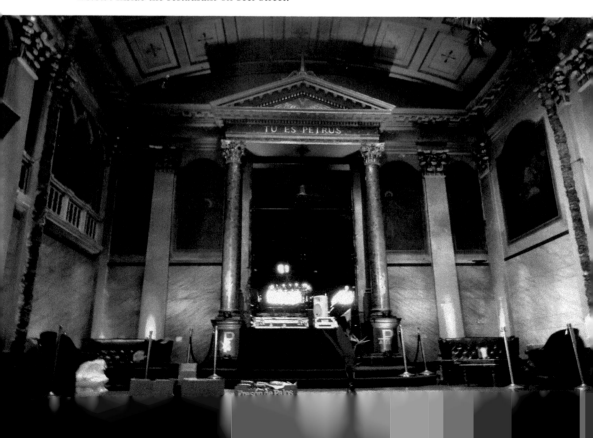

In 1864, the Lady chapel was built and the Lady altar was erected in 1898. Electric lighting was fitted in 1920 and in 1976 the church was transferred to the Polish community; for a short time it was known as Our Lady of Częstochowa. The church was deconsecrated in 1993.

Early in 2004, it was announced that developers had discovered the body of Father Bede Brewer in the crypt of St Peter's. He was one of the founding members of Ampleforth College of 1802 and President of English Benedictines. Father Brewer was reburied at Ampleforth Abbey in July 2004 together with the remains of six other monks. A bar and restaurant called Alma de Cuba was opened in the St Peter's Church building in 2005.

43. Liverpool Metropolitan Cathedral, Mount Pleasant

The Liverpool Metropolitan Cathedral was designed by Frederick Gibberd and was completed between 1962 and 1967. Richard Downey was appointed archbishop in 1928 and declared that he would build 'a cathedral in our time'. A 9-acre site in Mount Pleasant was acquired in 1930 and Edwin Lutyens was commissioned to design the new building. Lutyens proposed that the cathedral would be 680 feet long and 400 feet wide, with a dome of 168 feet, rising to 510 feet. It would have been larger than the Anglian Cathedral and St Peter's in Rome, and would have been the second largest church in the world.

It was to be built with buff brick and grey granite dressing and work commenced on the project on 5 June 1933, but only the crypt was actually completed. The work on the crypt was stopped during the Second World War and Lutyens died in 1944, the Archbishop Downey nine years later.

The Catholic Church soon realised that the scheme was becoming too large and expensive and Adrian Gilbert Scott looked at a smaller version of the building in 1955. However, a competition for a new design was announced in 1959 and it was specified that the building would be designed to allow for closer involvement of the congregation of 2,000 worshipers, all in sight of the altar. A decision was made to award the contract to Frederick Gibberd whose plan involved a central altar and incorporated the Lutyens crypt.

The building is contained in a circle of 195 feet in diameter and is surrounded by thirteen chapels, the main entrance and two side porches. There are sixteen boomerang-shaped concrete trusses, which rise vertically and then slant inwards, supporting the roof of the central space. The buttresses were not part of the original plan but were suggested by the engineer James Lowe.

The metropolitan cathedral cost £1.9 million and took five years to build. However, by the 1990s, it was necessary to repair various leaks and other problems that had developed since the cathedral was opened. The frame of the building has now been clad in mottled grey glass reinforced with plastic, the conical roof has been renewed in stainless steel and the podium repaved with concrete flags. The restoration was completed by Vis Williams Pritchard and the repairs of the crypt and piazza by O'Mahony Fozzard. A £3 million refurbishment of the crypt was completed in 2009 which included new east and west approaches, archive provision, rewiring and new lighting, catering facilities, a new chancel, new toilets and revamped exhibitions. The cathedral has been nicknamed 'Paddy's Wigwam' and 'The Mersey Funnel' by local people.

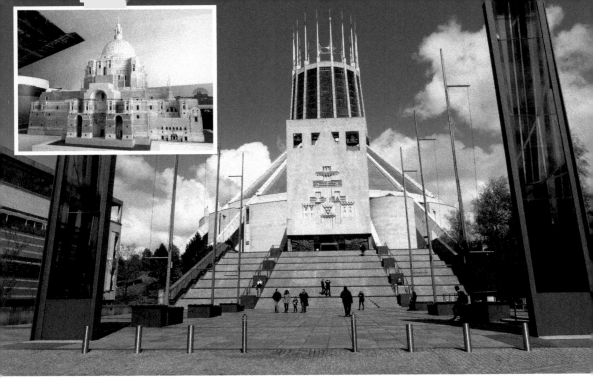

Above: The main entrance to the Metropolitan Cathedral.
Inset: Model of the original cathedral in the Museum of Liverpool.

Below: The altar in the Metropolitan Cathedral.

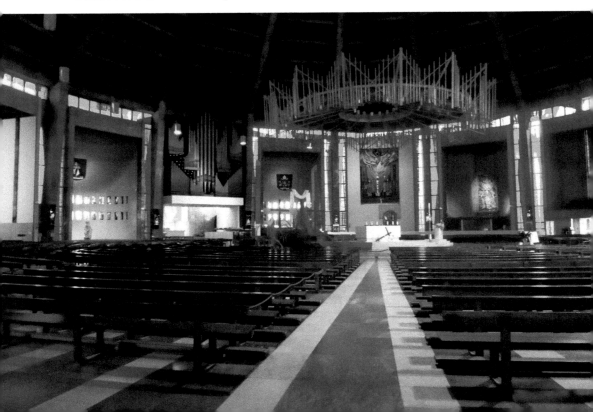

44. Liverpool Anglican Cathedral, St James's Mount

Built on St James's Mount, the Anglican Cathedral is the largest in the UK and the fifth largest in the world. The official name is the Cathedral Church of Christ in Liverpool and it is dedicated to Christ and the Blessed Virgin. The first Bishop of Liverpool was Revd John Charles Ryle who was installed in 1880 when the city did not have a cathedral, only the parish church of St Peter's. A competition to design a new cathedral attracted over 100 entries and Giles Gilbert Scott's design was chosen with George F. Bodley to oversee the detailed architectural design and building work.

The foundation stone was laid by Edward VII in 1904 and the Lady chapel was opened in 1910. The original design was altered to incorporate a single tower and the church was consecrated in 1924. The tower was completed in 1942 and work continued until the building was finished in 1978. However, Scott died in 1960 and did not see his work completed. The first bay of the nave was nearly complete and was handed over to the Dean and Chapter in April 1961.

Frederick Thomas succeeded Scott as architect and the building was opened by Elizabeth II in October 1978 followed by a service of thanksgiving and dedication. The cathedral's west window is by Carl Johannes Edwards and the uppermost window is the Benedicite window. A pink sign by Tracey Emin reads, 'I felt you and I knew you loved me' and was installed in 2008 when Liverpool became European Capital of Culture.

The building is 619 feet long and has an area of 104,274 square feet. The cathedral was built of local sandstone quarried from the Liverpool suburb of Woolton until this was exhausted and other sources of sandstone were found in the north-west of England.

Early images of the Anglican Cathedral.

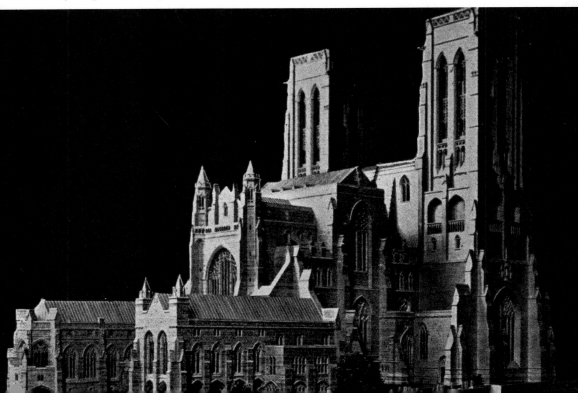

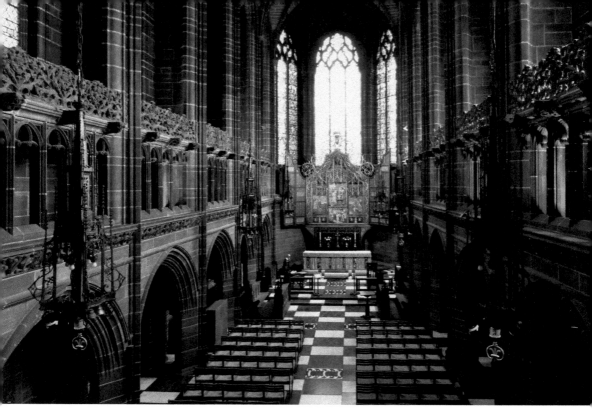

Inside the Liverpool Anglican Cathedral.

45. University of Liverpool

University College Liverpool, founded by royal charter in 1881, was admitted into the Victoria University, Manchester, in 1884. The Victoria Building was completed between 1887 and 1892, and designed by Alfred Waterhouse to house University College before it became the University of Liverpool.

In 1903, the University of Liverpool was established by royal charter and University College was absorbed into it. The college had ninety-three students, eleven professors and an income of £6,000. It is situated on the corner of Brownlow Hill and Ashton Street and was built with accommodation for administration, teaching and also incorporates common rooms and a library.

The Victoria Building includes a large entrance hall, 68 feet by 30 feet, a senate chamber, 27 feet square, a large theatre and the Jubilee Tower, built by public subscription in commemoration of the year 1887. The chiming clock was given by Sir W. P. Hartley and the library, with its timbered roof and recess for study, was the gift of Sir Henry Tate. The building was the inspiration for the term 'redbrick university' used by Professor Edgar Allison Peers and was converted into a museum and gallery in 2008.

University College Liverpool was established in 1881 and the Liverpool University Press was founded in 1899. It was a founding member of the Russell Group in 1994, which is a collaboration of twenty leading research-intensive universities, as well as a founding member of the N8 Group in 2004.

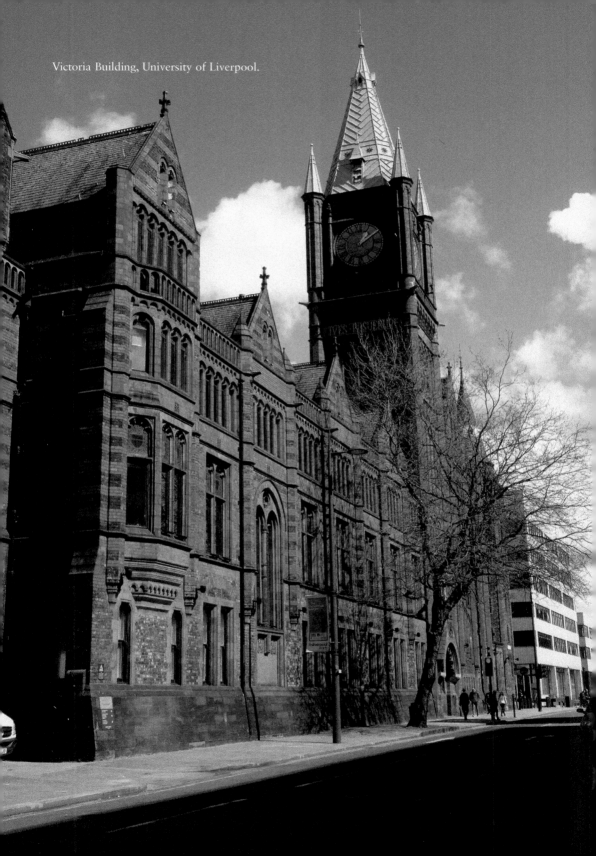
Victoria Building, University of Liverpool.

46. No. 62 Rodney Street

No. 62 Rodney Street was built in 1796 and is the birthplace of William Ewart Gladstone. He was born there on 29 December 1809 and was the son of a prosperous merchant. The house originally stood detached with a wing on either side but one wing was later altered and converted to a separate dwelling. It is a large five-bay house with the centre three bays projecting slightly and crowned by a pediment.

Gladstone was educated at Eton College and the University of Oxford and he was elected to Parliament in 1832 as a Tory. He held junior offices in Robert Peel's government of 1834–35 and entered Peel's cabinet in 1843, becoming a Liberal-Conservative in 1846. Gladstone joined the Liberal Party in 1859 and became their leader in 1867 and prime minister the following year. He disestablished the Irish Protestant Church in 1869 and was defeated by Benjamin Disraeli in a general election in 1874. He then retired as Liberal leader, became prime minister again in 1880, but his government was defeated in 1885 and he resigned. He was prime minister for a further time in 1886 and 1892 and devoted a great deal of time to issues concerning home rule for Ireland. He resigned in 1894 and died of cancer on 19 May 1898. Gladstone was buried at Westminster Abbey.

No. 62 Rodney Street, birthplace of William E. Gladstone.

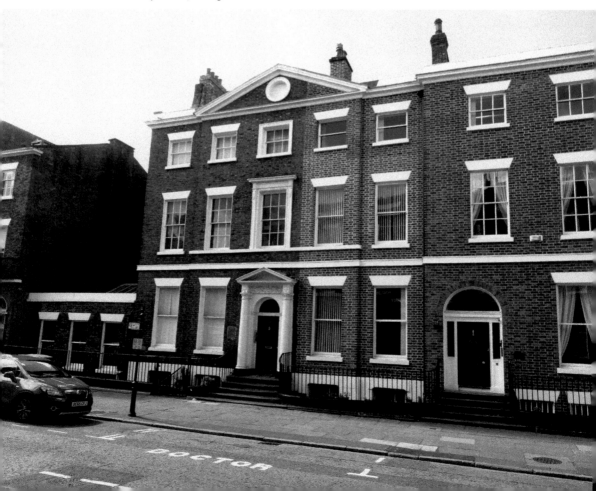

47. Liverpool Philharmonic Hall, Hope Street

The Liverpool Philharmonic Society was formed in 1840 and John Cunningham prepared plans for a concert hall in 1844. The foundation stone of the hall was laid in 1846 and it was completed in 1849 at a cost of £30,000. It was originally planned to build a hall with a capacity of 1,500 people but this was increased to accommodate an audience of 2,100, an orchestra of 250, and refreshment and retiring rooms. *The Times* reported that it was 'one of the finest and best adapted to music', and the hall was universally agreed to have superb acoustics.

On 5 July 1933, the hall was destroyed by fire and Herbert J. Rowse was commissioned to design a new hall to be built on the same site. The building was insured and the exact cause of the fire was never known, only that it originated in the roof of the building. The new Philharmonic Hall was opened on 19 June 1939 with a concert conducted by Sir Thomas Beecham performed the following day. An extension was added to the rear of the hall in 1992 and it received a substantial refurbishment in 1995 at a cost of £10.3 million. This included the replacement of the fibrous plaster interior with concrete, carried out by Brock Carmichael working with Lawrence Kirkegaard Associates.

The Philharmonic Hall now stages around 250 events each year. It is built with fawn-coloured facing bricks and is mainly in three storeys. Inside the entrance to the hall is a copper memorial to the musicians of the *Titanic* by J. A. Hodel and on the landings are gilded reliefs of Apollo by Edmund C. Thompson.

A recent view of Liverpool Philharmonic Hall.

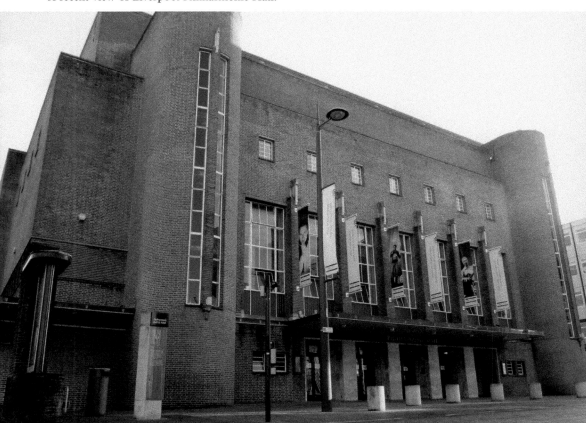

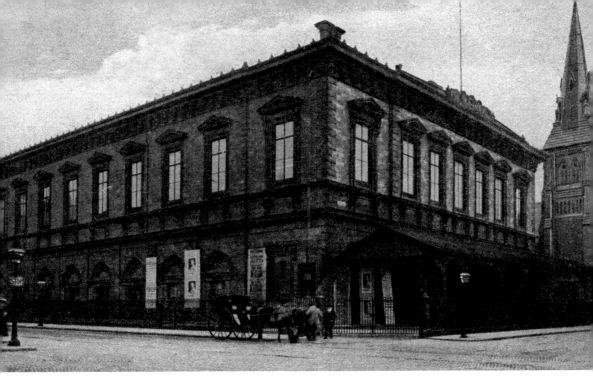

An early image of Liverpool Philharmonic Hall.

48. Stanley Dock Warehouse

At the end of the nineteenth century, the increase in the importation of tobacco into Liverpool necessitated the building of a new warehouse. As the King's Dock Tobacco Warehouse was needed in connection with the reconstruction of the Brunswick-Wapping Dock system, it was decided to build a large warehouse at Stanley Dock in 1901. It was designed by A. G. Lyster and enabled tobacco to be stored on one site, the north and south blocks of the existing warehouse in Stanley Dock having been used for this purpose.

The new building is 725 feet long, 165 feet broad and 125 feet high from the street level. It contains a basement, a quay floor and twelve upper decks. The block is divided into six compartments, each of which is served with quick-running lifts and is fire-proof. The warehouse has accommodation for 75,000 casks and it was estimated that 27 million bricks and 6,000 tons of iron were used in its construction. The floor area is approximately 36 acres and is claimed to be the world's largest building in terms of area.

The increase in imports of tobacco made the warehouse insufficient and almost the whole of the upper floor space at the Albert Dock Warehouse and the Wapping Dock Warehouses were later bonded for this purpose. An extension to the South Block of the Stanley Dock Warehouse was opened, in addition to twenty-four warehouses in Blake and Rodney Streets at Bootle.

The warehouses were damaged during the Second World War and, as trade through the port declined in the 1980s, they fell into disuse. Plans have been submitted to redevelop the building into 476 apartments, together with cafés and retail outlets on the ground floor. The north warehouse was restored and reopened as a hotel in 2014. The eastern end was

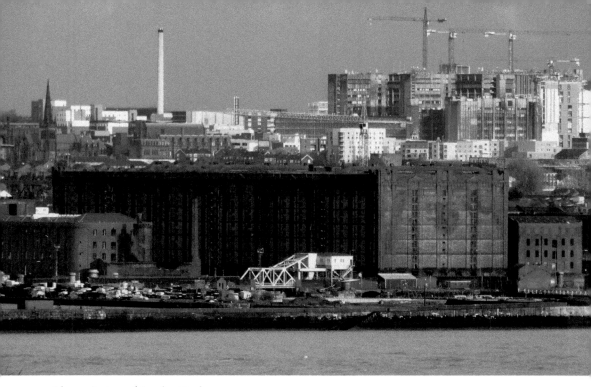

Above: A view of Stanley Dock.

Below: Stanley Dock Warehouse.

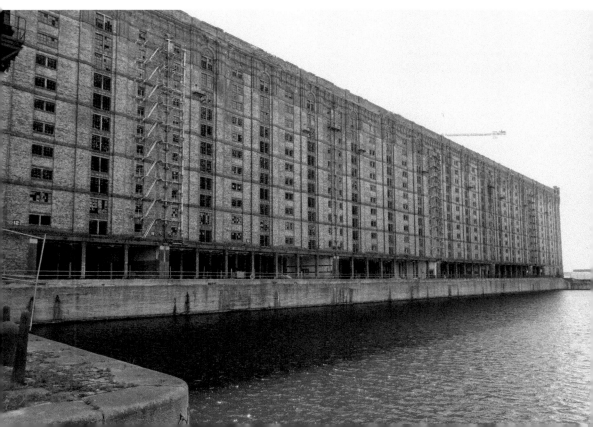

replaced by a single-storey addition in 1953 and was used to store rum and this is now used as a conference centre.

49. Speke Hall, The Walk

The estate at Speke was mentioned in the Domesday Book of 1086 as 'Spec' and in the fourteenth century it came into the hands of the Norrises of Sutton. Construction of the present hall began in 1530, although earlier structures had been built on the site, which are incorporated into the present building.

The Great Hall was built in 1530, followed by The Great (or Oak) Parlour, which was added the following year. The North Bay was added between 1540 and 1570 and the South Wing was altered and extended. The West Wing was built between 1546 and 1547 and the North Range by Edward Norris. The oak frame rests on a base of red sandstone surrounded by a dry moat. The main beams are stiffened with smaller timbers and filled with wattle and daub.

The hall is a well preserved specimen of half-timbered black and white Elizabethan architecture. It contains a thunderbox toilet, a priest's hole and an observation hole built into a chimney in a bedroom to allow people in the house to see approaching visitors. There is also an open hole which allowed servants to hear conversations of people waiting at the front door. The Great Hall contained pieces of wainscoting and a number of volumes said to have been brought from the royal library at Holyrood by Sir William Norris in 1544.

An early image of the Speke Hall estate. *Inset*: The Great Hall, Speke Hall.

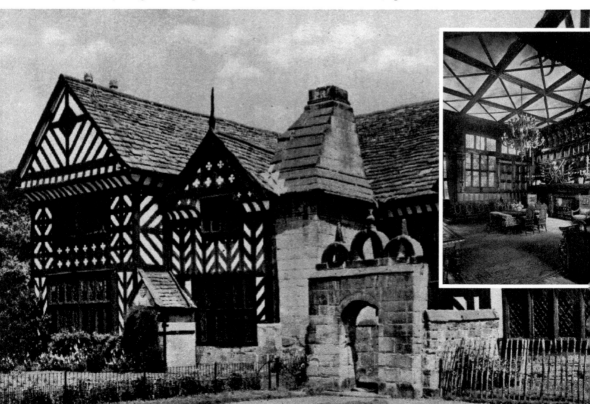

The house was owned by the Norris family for many generations until the marriage into the Beauclerk family. The house was acquired by the Watt family from the Beauclerks in 1795. Miss Adelaide Watt died in 1921, leaving the house to pass into the ownership of the National Trust in 1942, administered by Liverpool Corporation until 1986.

The Home Farm building is now the shop, restaurant and reception area, and the laundry has been converted into the education room. The Jacobean plasterwork is complimented by the intricately carved furniture and the fully equipped Victorian kitchen and servant's hall. There are woodland walks and views of the Mersey Basin and the hills of North Wales.

50. Croxteth Hall, Croxteth

The estate at Croxteth can be traced back to Barret, who was linked to John of Gaunt in the fourteenth century. It was acquired by the Molyneux family in 1473, who were also awarded land at Sefton and made it their seat.

The original house was built in 1575 and has later been extended in Tudor, Georgian and Queen Anne styles. The front, the west façade, was built in 1707 and the timber-framed building was encased in brickwork in 1805. The house gradually became the Molyneux's main property and Sefton Hall was demolished in around 1720. The park was laid out in 1850, the East Wing rebuilt in 1875 and the West Wing in 1902.

A view of Croxteth Hall.

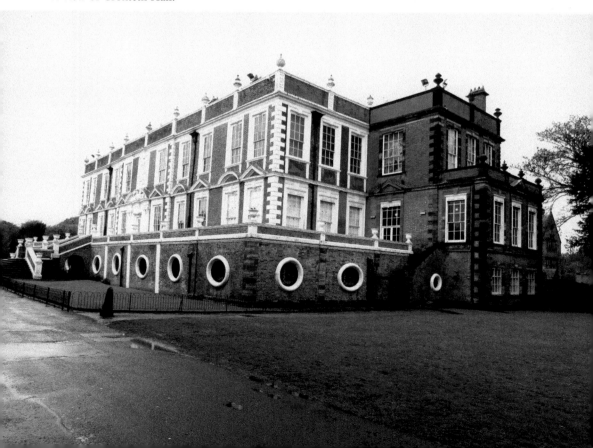

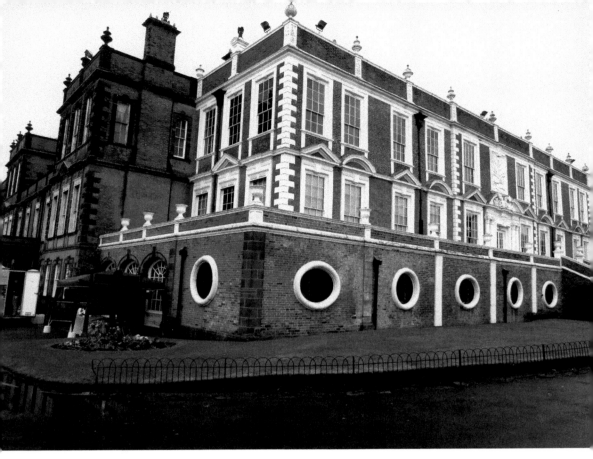

A recent view of Croxteth Hall.

Queen Victoria, Prince Albert and their children stayed at Croxteth Hall on 9 October 1851, prior to their visit to Liverpool the following day. The royal party entertained over 700 local people in the grounds of Croxteth Hall during the visit.

The last earl died in 1972 and an unsuccessful search was made for an heir to the title. The American widow of the earl, Josephine, Countess of Sefton continued to spend time at the hall until her death in 1980. Much of the estate has been sold off for development, but 500 acres remain as a country park that is open to the public.

The gardens contain one of the oldest horticultural collections in Britain, founded by William Roscoe in 1802. There are *Dracaena* (dragon trees), orchids and the National Collection of *Codiaeum* (garden croton), *Pelargonium* (geraniums) and *Solenostemon* (coleus plants) as well as a collection of bromeliads.

The park is Grade II-listed and contains Mull Wood, which is part of Croxteth Local Nature Reserve. In partnership with Lancashire Wildlife Trust, the reserve has doubled in size, allowing people better access to it and new habitats within the area.